# LOST
## TOWNS OF
## MASON COUNTY
## MICHIGAN

Best Wishes
Sandi Lewis - Mallery

# LOST
## TOWNS OF
## MASON COUNTY
## MICHIGAN

*Sandi Lewis-Malburg*

THE
History
PRESS

Published by The History Press
Charleston, SC
www.historypress.com

*Front Cover, bottom*: Fern School operated from 1880 to 1957 in Eden Township. *Photograph by Melissa Anderson.*

*Opposite page*: Collette Pitcher created the *Helping Hand* sculpture of a police officer in front of the Mason County Sheriff's Department. *Author photograph.*

First published 2019

Manufactured in the United States

ISBN 9781467142656

Library of Congress Control Number: 2019932536

*Notice*: The information in this book is true and complete to the best of our knowledge. It is offered without guarantee on the part of the author or The History Press. The author and The History Press disclaim all liability in connection with the use of this book.

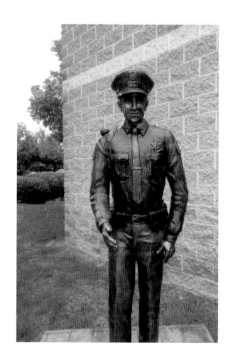

*Dedicated to Trooper Paul Butterfield*
*and ALL who watch over us.*

# CONTENTS

# PREFACE

ave you ever been swimming at Stearns Park or out on the curves north of Ludington and thought you heard the faint sound of horses neighing or a wagon rattling down the road? If you live in the rural townships, have you ever heard a far-off, high-pitched whistle of a train as it rolls clickity-clack down the rails? Those of us in the rural areas are used to all kinds of sounds as farmers work through the seasons, but some sounds don't seem to fit the area. Is it our imagination, or is it that sound traveling miles from town? Or could it be echoes of the past from the bygone places in Mason County?

A hundred or so years ago, Mason County was a different, harsher place. The people, many ancestors of today's county residents, were different. They were hardy pioneers, many of them immigrants, who came by foot or boat to settle on their homesteads and help carve a place out of the forest that went nearly right up to Lake Michigan. Like other spots in Mason County, Ludington Avenue was a spring-riddled swamp, and today's rural wheat and corn fields might have been a bustling small settlement. Did these people leave traces that they were here? Did they disappear, lost to time? Let's see!

Although a 1971 transplant to Mason County, I have spent most of my life here. I can remember hearing of the various places in the county from the elders—while not eavesdropping on adult conversations, of course. Some of these places have become modern towns, but most are gone, abandoned or covered over by time. Some would call them ghost towns.

While researching this book, unfortunately, I haven't heard of many ghosts, except for a young woman who said that as a young girl she was told of a "Purple Lady" (a lady in a purple dress) who walks around by Pere Marquette Cemetery. Have you seen her? Could she have been from old "Polish Town?"

Many of the bygone settlements in Mason County were given their names before there were roads in the county and before cars made it easy to get around. Many of the settlements had several names as the years went by. Why, I wondered?

I am a genealogy buff. I can spend hours a day searching online for information and documents about my ancestors. Along the way, I've met many others who feel the same. Unfortunately, many people may not have access to online genealogy and newspaper sites. I wanted to find a way to help make this information available for everyone. I have found gravestones to be great sources of information—most give birth and death dates. This information can lead to more information. I chose the Find a Grave website as my way to help others. I began photographing the headstones in the cemeteries south of U.S. 10. It took me years, but eventually I had a CD of my photographs, and I took it to the public library to make it available for others. It was there that a library worker asked me about copying obituaries from old issues of the *Ludington Daily News*. With her guidance and that of David K. Peterson, I started with the first paper available online and went page by page searching for death notices.

It was difficult, as there was no order to their placement—they were stuffed anywhere they would fit in the paper. Another problem was that the obituaries mentioned people from places that no longer exist in the county. The places in the local columns didn't match up with the places I knew today. I knew where the families I knew lived, and I could look in those cemeteries, but many of the families lived in a different area of the county than their descendants. I began writing down these places. By the time I got to the 1917 papers, my notes nearly filled a Steno book. There were so many more places than I imagined. Who knew?

Because the names of places are important, I decided to put them into a book that could be made available to the public and at our local library.

WHY DOES THE NAME of a place change? Why did the people move about so?

There are many reasons, but the main one is probably time. Places are often named for the first settler, a longtime (or well-respected) resident, or

even a loved one. As time goes by, these people and their importance are forgotten, and the place might be renamed for a current person or family. One of the road names in the old Tallman Village was Butters Avenue. It bore the name of the Butters family, who owned the mill on Tallman Lake (and Buttersville) and platted the village. In this case, you will have to read about Tallman Village to find the importance of this road today.

Places were also named for local features. Say you need something picked up at Sand Castles, the children's museum, and want to send your teenager to get it. What is near the museum that they might know? It is on the corner of Ludington Avenue and Harrison Street, across from the Ludington Post Office, so you might call it Post Office Corner or Museum Corners, and the name sticks. In fact, I've heard the intersection called Elk's Corner, as Sand Castles is in the old Elk Lodge.

Other places were named for their purpose. Fire Tower Hill, in Oceana County, was the location of a government lookout tower to watch for forest fires. I remember my brother and his friends getting on dirt bikes for a challenging ride scaling the hill.

Let's not forget about people buying land and renaming it for themselves or someone they love. I was told that Nugent Lake, in Sweetwater Township, Lake County, was named for hard rocker Ted Nugent after he purchased the land around the lake.

Then you have flat-out bribes; the city of Ludington comes to mind. James Ludington offered a donation (or as James Cabot suggests, Luther Foster may have done it on Ludington's behalf) for the city to be named after him. It was, and he platted out the city. He (and Foster) changed the two main streets to James Street and Ludington Avenue. Many of the city's north–south streets were named for Ludington's siblings and family, including Gaylord, Lewis, Charles, Emily and Amelia. The city's east–west streets were given the names of his cronies, including Filer, Melendy and Foster.

After a while, people forgot about James Ludington's family, and Charles Avenue was renamed Rath Avenue after William Rath, a lumber businessman and former mayor.

BEFORE MOVING ON, A few notes:

I have attempted to provide accurate maps to help readers know where these places were. Right up front, I am NOT an artist. My maps are not to scale. I started drawing them by hand, and although I was proud of the result, they weren't of publishable quality, so I tried to reproduce them on

my laptop. The rivers didn't come out as I wished and might be a bit off, but I'm sure you'll get the idea. Furthermore, when many of the places in this book were busy settlements, most modern roads in the county did not exist, so I use today's road names to better give you an idea of the location.

I frequently refer to two Mason County Historical Society publications: *Historic Mason County* and *Mason Memories*. As far as I'm concerned, this society, of which I am a member, is the best source of correct information on the places in Mason County. I do occasionally disagree with the information in these publications, but in no way is that meant to discredit the author or the publication. It has to be remembered that most of the authors who wrote the articles in these publications are volunteers, not professional researchers or historians. Most are retelling stories they heard or telling stories from their memories. It was how they saw it or heard it. Quite a few were childhood memories, and we all know how different the perspective of a child and adult can be or even the difference between how two people can see things. A common story comes to mind of a little rural Mason County girl who, without permission, tried to follow one of her parents through the woods one day and got lost. I have read three or four versions of this story, and the location varies. When she got tired, she sat down and cried. She said a big black dog came, licked her face, laid beside her and kept her warm, as a dog will do. After the adults realized she was missing, they did a search. As they approached her location, they saw a black bear running away. The girl was disappointed that the adults scared the big dog off.

When these publications were created, there were none of the computers or other digital resources that are available for us. In fact, during my research, I found that many of the articles or notes were written on newsprint, the backs of envelopes and previously used paper. I even found some written on cardboard, like a cereal box. The resources available to us today make a world of difference. These people did the best they could with what they had at the time, which was excellent. In their own way, they were pioneers working tirelessly to preserve the past for us. Their articles are important parts of our past and should be honored as such. Thank you all!

# ACKNOWLEDGEMENTS

I came to Mason County when I was eleven years old and adopted it as my home. Writing this book is my way of saying thanks to a place and its people that I love.

I would also like to thank all who have mentored and helped me in this publishing process. Thanks to those who took the time to talk with me and answer questions: David K. Peterson, Dr. William Anderson, Professor Mike Nagle and Barry Matthews for guidance; Bob Kosonovich of Book Mark for advice and assistance; Michelle De Kuiper and Lori Sutherland at Historic White Pine Village for their patience and assistance during my research and photo gathering; Melissa Anderson for helping me with images for the cover—this woman has a gift for photography; the Ludington District Library staff; members of Remembering Scottville and Vanishing Ludington social media sites for answering endless questions and providing photographs; John Rodrigue, of The History Press, for all his help and advice along the way; my sisters and brothers for cheering me on; my sons and daughters-in-law for assistance; and my grandchildren for letting grandma work. Thank you so very much.

# INTRODUCTION

I always thought the history of our county, or at least the version I learned in school, was etched in stone: the first white person to touch our shores was Father Jacque Marquette. The Pere Marquette River was named for him. The Pere Marquette was originally called Not-a-pe-ka-gon, which means "heads on sticks." Mason County was named for Governor Stephen T. Mason, the "Boy Governor." The first white settler came in 1842, and we became a county in 1850. People first settled along the shore and then spread east along the rivers. Or did they come from the east and spread west?

There has been some disagreement as to the history of the county. As we move ahead in time, we find new information and become aware of flaws in old information. For example, *Historic Mason County* (1980), created by the Mason County Historical Society, states that Notipekago County was established by the state in 1840 and that the name was changed to Mason County in 1850.

The county historical society later corrected this by reprinting an article from the Ottawa County Historical Society in *Mason Memories* (1987) with a map of Ottawa County in 1850 in which Mason and Oceana Counties are listed as White River Township. It explains: "On March 28, 1850 Mason and Oceana counties were considered unorganized townships and were named as White Lake Township and part of Ottawa County by public act 176."

It then says that on February 13, 1855, the state legislature passed Public Act 171, organizing Mason and Oceana Counties. The original Mason County consisted of three townships: Pere Marquette, Sable and Freesoil.

Pere Marquette Township began on the south shore of Sable (Lincoln) Lake and River and continued south (including Ludington, which did not exist at the time) and east to Oceana County. Sable Township began at the northern bank of the Sable (Lincoln) Lake and River, including the Hamlin area east to Lake County. Freesoil Township began north of Sable at Lake Michigan and extended to Lake County.

A county board of supervisors was formed. People were moving eastward in the county. Why? Perhaps they were seeking the opportunity for a better life, the grass was greener or there was just no work or a lost home. Maybe all of the above. In these townships, research reveals two cities, six villages and a total of thirty-nine past settlements.

What is considered a settlement? Basically, it is a previously unsettled place where a community becomes established. It could be anything from a single farm family to a whole metropolis. The majority of our settlements were not the first, and none of them were the latter.

*National Geographic* says that humans seldom live in isolation; we tend to cluster together. There are many reasons for this, but it is usually to satisfy a need or function. We have all heard of there being safety in numbers. The settlers came to a wild country. The first homes had no doors, just blankets covering the openings. Clusters of homes made it less likely that an animal would enter the area and increase chances of survival if one did. Companionship is another reason. Seldom did the settlers move in with the Native American population. They didn't speak the language, although many settlers were helped by the Native Americans. Language is one of the major reasons for some of the communities in this area: we had Polish Town, Finn Town, Danish Settlement, Swedish Settlement, German Settlement, and the Lithuanians in the Scottville and Custer areas. Having similar language, customs and background makes a big difference. Having others nearby to help, does too. In the old days, the members of the community all chipped in and helped. The more people in the settlement, the more people to share the burdens. Everything from building a home or barn to planting and harvesting crops to making maple syrup and jam were tasks that the community shared. When families butchered a cow or steer, the community helped, and all shared in the profit. In the days before electricity and freezers, it made absolute sense—there was less loss or spoilage. Also, the unfortunate or new settler would be helped along the line and would give back to the community in other ways. Another reason to cluster in communities was employment. Most of the time, wherever a lumber camp or mill popped up, so did a small settlement, and the opposite is true, as well—when a camp or

mill closed, the community usually did, too. Some lumber camps provided housing for families (or supplied the materials to build a home). Some only housed their workers in tents so they could pack up and move along to the new campsite.

Settlements arose where the needs of the people were met: ports need access to deep water; farmers need arable land; the lumber industry needs forests. Those settlers whose needs were not met in the community needed to be able to travel to another that could fill the need.

As time went by, new settlements were founded and grew. However, the amount of county money spent on lakeshore communities didn't change. The outlying settlements got little, and they wanted to separate from Lincoln to more equally divide county funds among the townships. Eventually, the three townships grew to thirteen, and then to sixteen: Grant, Freesoil, Meade, Hamlin, Victory, Sherman, Sheridan, Lincoln, Pere Marquette, Amber, Custer, Branch, Summit, Riverton, Eden and Logan. The Lincoln settlement later became a ghost town, and the township's land was absorbed by Amber, Pere Marquette and Hamlin, so today there are only fifteen townships.

# THE TOWNSHIPS OF MASON COUNTY, MICHIGAN

★ Bygone Settlements     ☆ Current Cities or Villages

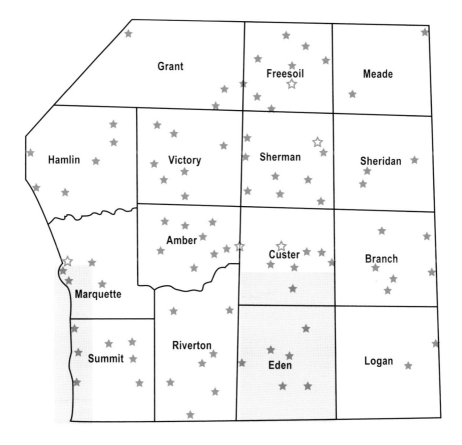

Indian Reservation and the Claybanks

# AMBER TOWNSHIP

A mber Township was created by the county board of supervisors in 1867. In 1873, it was bounded on the west by the city of Ludington, the northwest by Lincoln and the north by Victory. Its easterly boundary was Branch Township, and the Pere Marquette River formed the southern boundary. Scottville does not show up on the map at this time (it didn't exist yet), while Amber Station does. Custer Township had not been created.

Today located between Pere Marquette (to the west) and Custer Townships (to the east), Amber Township holds the busiest highway in Mason County. Many businesses have located along the U.S. 10/31 highway corridor for easier access for customers. Some speculate that the city of Ludington will expand eastward nearly to Scottville. Or perhaps a new Amber City will pop up.

One of the earliest settlements in Amber was Slaughterburg, also called Amber Corners at other times. It was located where Amber Road crosses U.S. 10/31. The settlement was named for Silas Slaught (or Slaughter), who came from Victory Township and owned and operated the general store. The original post office was in Slaughter's store.

When the Flint & Pere Marquette Railroad built its track south of Amber Corners, a station was put in. The post office was moved from Amber Corners south to the north side of the road where the tracks cross Amber Road. As you will see throughout this book, where there is a railroad station, a settlement

# Amber Township

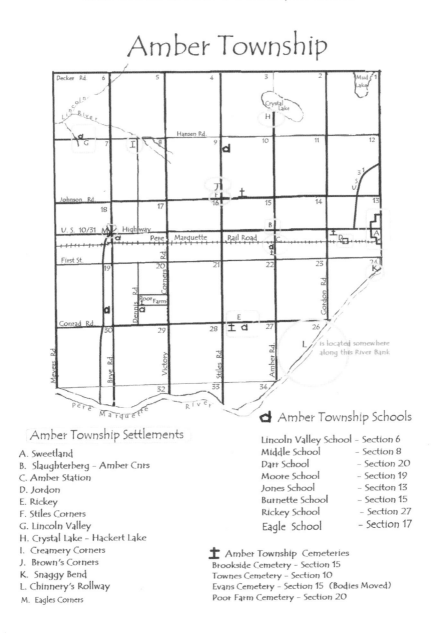

## Amber Township Settlements

A. Sweetland
B. Slaughterberg – Amber Cnrs
C. Amber Station
D. Jordon
E. Rickey
F. Stiles Corners
G. Lincoln Valley
H. Crystal Lake – Hackert Lake
I. Creamery Corners
J. Brown's Corners
K. Snaggy Bend
L. Chinnery's Rollway
M. Eagles Corners

### ⌐ Amber Township Schools

| | |
|---|---|
| Lincoln Valley School | – Section 6 |
| Middle School | – Section 8 |
| Darr School | – Section 20 |
| Moore School | – Section 19 |
| Jones School | – Seciton 13 |
| Burnette School | – Section 15 |
| Rickey School | – Section 27 |
| Eagle School | – Section 17 |

✝ Amber Township Cemeteries
Brookside Cemetery – Section 15
Townes Cemetery – Section 10
Evans Cemetery – Section 15 (Bodies Moved)
Poor Farm Cemetery – Section 20

usually forms. At this crossing, a new settlement, Amber Station (see image on page 24), grew. The land was originally owned by August Miller, and the railroad station had a general store, post office and icehouse. Across the road from the icehouse (on the west side), the town hall was built where it sits today. Just to the south of the tracks on the west side of the road was the Burnette

School. Nearby, to the west of the school on the same side of the road, was Evan's Cemetery. When the settlement dissolved, the cemetery closed, and the bodies were moved to other cemeteries in the township. Knox's Corners was about three-quarters of a mile from Amber Station, where Dr. Timothy Knox (of Victory) built a hotel. Cobb's Mill was to the west of the station. Once the railroad was built across Amber and not Victory, many Victory Corner residents relocated because of ease of transportation.

The county poor farm was a working farm to the southwest of Amber Station on Dennis Road between Conrad Road and First Street. The destitute and debtors were sent there by the county court to live, probably with their belongings (if any) being sold to pay their debts. Called inmates, they worked on the farm to help it support itself (possibly to pay off their debt). Many people, unable to get back on their feet, lived there until their deaths unless family took them in. The farm must have prospered, as it grew from forty to eighty acres between 1904 and 1915. A couple of death certificates prove that people were buried there. I had never heard of a cemetery being there, but township supervisor and former department of natural resources conservation officer Jim Gallie confirms that there was a cemetery on the poor farm.

To the northwest of the poor farm was Mosquito Creek, which crosses First Street and into Pere Marquette Township. Just to the south of the poor farm was the Charles Dahn farm, with the Darr School in its northwestern corner. To the southeast of the poor farm was the Rickey District. The Rickey School was located on the south side of Conrad Road between Amber and Stiles Roads. The community held weekly and monthly church and neighborhood meetings and funerals in the school. To the west of the school was the Rickey Cemetery, which survives today.

The south end of the township was bordered by the Pere Marquette River, which at that time was a hard-working river used to carry logs from the many lumber camps to the mills; to turn the wheels that powered the mills; and to ferry supplies, passengers and mail on flat-bottom boats to outlying mills and settlements in the county. It has been said that scows could travel as far as twenty miles upriver to make deliveries.

One particular prickly spot along the river between Scottville and Ludington was called Snaggy Bend. According to Supervisor Gallie, it lay along the Pere Marquette River's bank in Section 24. A little farther down the river to the west was Chinnery's Rollway (a rollway is a place or hill where logs are piled up and stored until they can be rolled down into the river and floated to the mill).

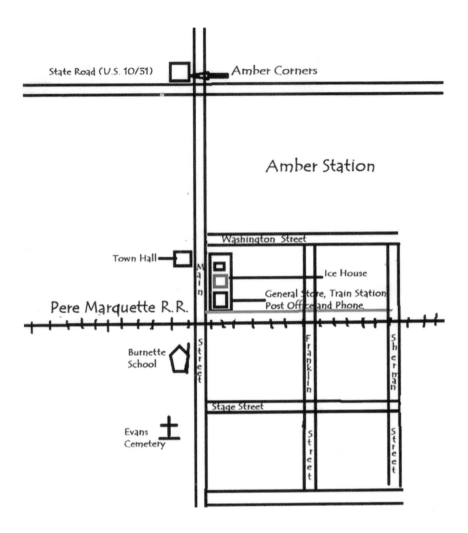

North of the river and east of Amber Station, between Amber and Scottville along the railroad tracks, was the settlement of Jordan. It was claimed to be halfway between the two settlements; on the maps, it looks a lot closer to Scottville, but it also may have been half a mile west or near where Great Lakes Energy and Acres Co-Op are today. A few old settlers stated that Jordan became Scottville. This is very possible, or one poorly located settlement died out, and another in a better location grew.

To the north and west of Jordan along U.S. 10 was Brookside Cemetery, owned by the City of Scottville, with burials both north and south of the road and east of the dividing brook. Elm Section is the oldest and largest.

Maple Section was added east and south of the brook and then Evergreen across the road. The cemetery contains the bodies of residents from the surrounding townships as well as Scottville.

Following U.S. 10/31 toward Ludington to Stiles Corners, which is what I've heard it called today, Brown's Corners was nearly in the same spot or just behind where Grassa's Farmers Market (as the township supervisor says) is today. Northwest of Stiles Corners, where Dennis Road meets Hansen Road, was Creamery Corners, which I would have guessed was farther east on the Howard Hansen property, east of Gordon Road, where my dad bought milk. But this creamery was on the Nels Jenson farm, at the southwest corner of Hansen and Dennis Roads.

Jones School, on the southwest corner of Hansen and Gordon Roads, was named for Charles Jones, who owned the property where the school was built. Many property owners donated land for the schools and even helped build them, and in appreciation, the schools were named for them.

Northwest of this was Lincoln Valley, which was formerly part of Lincoln Township before it was dissolved. Then it became part of Amber Township, and it is located in the northwest corner of the township. Lincoln Valley School District was a half-mile west of Brye Road on Hanson Road near Myers Road.

In my volunteer work, I frequently heard of Eagle's Corners, at the corner of Brye Road and U.S. 10. Eagle School was at the southeast corner of the intersection. One article states that Eagle's Corners was at Amber Corners, but in the community section of the paper, there is a column for both, which would lead you to believe they are different.

Heading back south, Towns Cemetery is on Johnson Road east of Stiles in the southeastern corner of the J.L. Towns property.

Scottville (see image on page 26) lies in both Amber and Custer Townships and was a regular stop on the Flint & Pere Marquette Railroad. It's probable that spot was chosen because it was where two state roads met, one going north–south and one east–west. Down the hill was the river, another form of transportation.

The city of Scottville was first named Sweetland after James Sweetland, an early settler who came from Victory in 1876 and bought a mill in Scottville in 1878 that he sold to Hiram Scott in 1879. There was apparently some problem with neighbors or the law, and he took his family west to Washington State (James Sweetland did indeed make it to Washington and died in 1911 in a powder keg explosion on his ranch on the Skokomish River). At that time, the name of the village was changed to Mason Center due to its location near the center of the county.

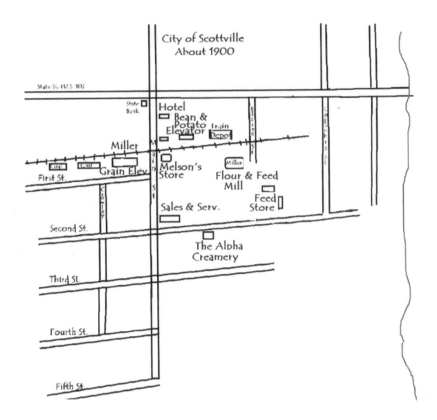

The original town was south of the railroad tracks, and the first store was owned by Harry Melson. The post office was in a general store, owned by James Crowley. If supplies came by train, they were just tossed off at the side of the tracks and left for the owners to locate and take to their stores. If one needed to get on the train or have it pick something up, it had to be flagged down. Local historian David Peterson says that back then, Scottville was a bit of a rowdy town, with street fights, gambling and riots, far from the quiet Scottville we know (in 2018, I read of an incident in which an ancestor residing in Scottville was arrested for shooting up Custer).

In 1882, Scottville became a city. The story I've heard over and over about how the city got its name was that two early settlers, Hiram Scott and Charles Blain, flipped a coin—Scott won, or so it seems. However, something much more gracious happened. David Peterson says on his website that the official story is that they did indeed have a coin toss, and the winner named the city and the loser named the streets. He says Blain won the toss and named the city after Scott. This is backed up by articles on the city website. Scottville

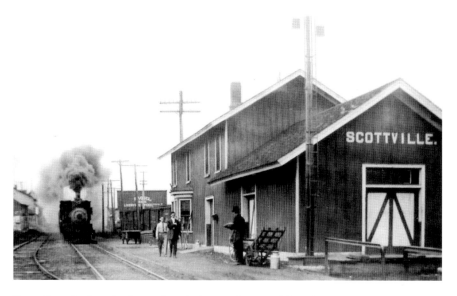

Scottville train depot in the south end of town. *Courtesy of Don Klemm.*

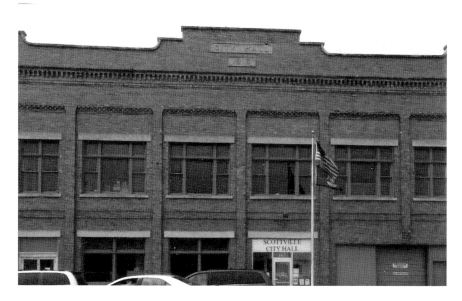

Scottville City Hall. The second floor was a hall where gatherings and dances were held. Today it is closed to the public for safety reasons. *Author photograph.*

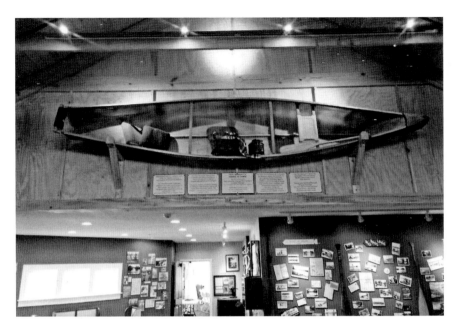

This Pere Marquette fiberglass canoe, built in Scottville in 1955, is on display at the Lake County Historical Museum. *Author photograph.*

did have a mill, called Eureka Mills, at the river, but whether this was the one owned by James Sweetland and Hiram Scott or one owned by the Foster family of Fountain is unclear.

According to the Lake County Historical Museum, the Pere Marquette Fiberglass Boat/Canoe Company was on West First Street in Scottville. The Industrial Fiber Glass Products Corporation was the parent company and was located at 800 South Madison Street in Ludington before the 1930s. The Pere Marquette Fiberglass Boat Company moved to Scottville by the early 1950s. Contrary to what my grandchildren think, I wasn't alive yet.

Why did Amber Station and Jordan fail where Scottville succeeded? A lot of Scottville's success lies in its location. In a day when there were no cars, travel was difficult. Scottville had the river and the railroad to get people and supplies about, and it had the state road to travel north, as well as the one good road with a good bridge to get people across the river from the south. It was their town.

In addition to the old school districts mentioned earlier, the Moore School was at the corner of Conrad Road and Brye Road, and Amber District Two was on the east side of Stiles Road just south of Hansen Road. Today, all the schools have consolidated with Mason County Central Schools, and the

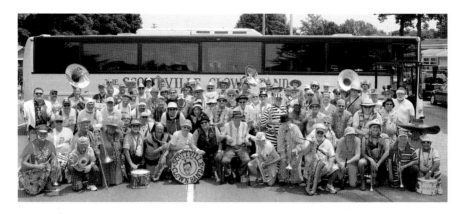

The Scottville Clown Band is famous all over the world, as its bass drum proclaims.
*Photograph by Russ Miller, with the permission of the Scottville Clown Band.*

only settlement left in the township is the city of Scottville. The school is the largest employer. Sadly, the Roach Canning Factory, which became Stokely's Bean Plant, has gone out of business.

Today, the factory (in Custer Township) serves as a Gourmet Mushroom Plant. The local grocery and drugstores have closed, leaving just two furniture stores, insurance companies, the North Town Café, Charlies Bar, a dollar store, four gas stations and a bait shop. All the others moved to Ludington or just went out of business. Off Amber Road north of Scottville and Hansen is Hackert or Crystal Lake, which still has public access off Hansen Road.

# 2

# BRANCH TOWNSHIP

Founded in 1871, Branch Township today is, to the untrained eye, a couple of yellow blinking lights along the highway seen through the forests on the way east or west on U.S. 10. For the rest of us, it is snowmobile heaven or a great place to put the canoe or drop a line in the Pere Marquette River. In days past, it was a vital series of booming lumber camps, with several active communities settled mostly by Civil War veterans and immigrant loggers. The first gravel roads did not come until 1912.

Having few settlers in the pine wilderness, it was at first divided into two settlements. North Town was not a town at all, but if you lived alone in the vast wilderness and came across a place with twelve people, it must have seemed so. North Town was north of the Pere Marquette River, and thus South Town was south of the river and includes all Logan Township. There weren't a lot of people—probably less than seven or so families. The first Branch Township meetings were held at a Louke's lumber camp on the river east of Walhalla. The name "Branch" is thought to pay homage to two of the early settlers who came from Branch County, Michigan, down by the Indiana border.

The settlement of Branch is on the line of Mason and Lake Counties. The original settlement began with the Barnett Hotel and its post office was on the south side of Young Road (which runs between Masten and Tyndall Roads south of U.S. 10 and the railroad tracks). The community formed around the Pere Marquette and Flint Railroad's Branch Station (see image on page 32), on Young Road near the post office and just before Lake County line. Branch

# Branch Township

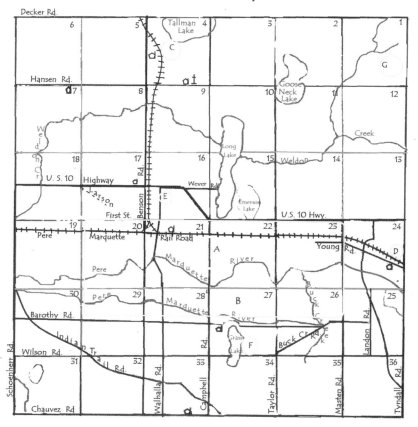

## Branch Township Settlements

A. North Town
B. South Town
C. Tallman Village
D. Branch
E. Manistee Junction – Merritt – Walhalla
F. Grass Lake Settlement
G. Swedish Settlement

✝ Branch Township Tallman
   Village Cemetery

## Branch Township Schools

Center School – Section 22
Grass Lake School – Section 27
Tallman School – Section 4
Branch School – Section 24
Comstock School – Section 7
Walhalla School – Section 17

Note: 1915 plat map shows another school
in section 4.

School was on the east side of Section 24. This was on the east side of Branch Road in Lake County per *Historic Mason County*, but the old plat maps show a school in Section 24 south of the tracks and Taylor Road.

Most literature says that the Flint & Pere Marquette Railroad got its name because it ran from Flint to Pere Marquette Village and back. When the line was extended to Detroit, it became the Detroit & Pere Marquette; when it went farther, the "Detroit &" was dropped and it was called the Pere Marquette Railroad. It seems that this might be truer than those on the other side of the state contend. They state that the truth is that the railroad had the Pere Marquette name long before it came to Pere Marquette Village. It was done in honor of the Jesuit explorer.

In the 1880s, Butters and Peters Lumber Company bought land near Grass (Tallman) Lake and brought in a portable sawmill, building a company store and later a permanent sawmill on the lake that employed as many as 150 people. The settlement of Tallman was originally called Wever (and Ashe's Corners). It's possible that Tallman rivaled Scottville in size, with a boardinghouse, stores, schools and post office. Per *Historic Mason County*, Tallman School was located on north side of Marshall Road south of the lake. However, the centennial village map does not show this. It has one school on the east side of Maggie Street south of Butters Avenue and another east of Goff Street near the Evaline Street intersection.

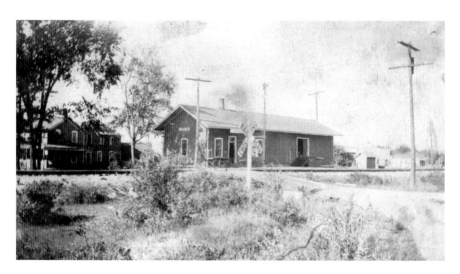

Old Branch Station on Young Road in Branch. Note the hotel across the road. *Courtesy of Lake County Historical Society.*

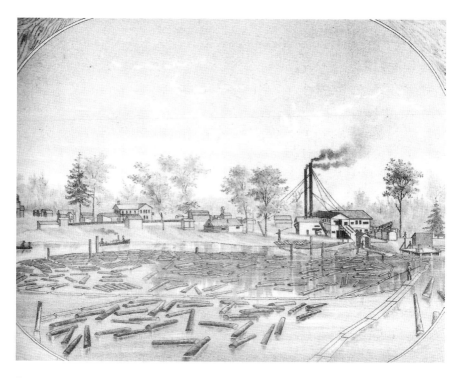

Butters and Peters mill on Tallman Lake. *Drawing from* Mason County History, *1888.*

There are at least two accounts of the naming of Tallman Lake and settlement. The first one is that H.C. Tallman put up a mill and the area was named for him, but the more probable story is that Butters and Peters built a mill on the lake and H.C. Tallman, Horace Butters's brother-in-law, fronted the money for the venture and so Butters named the settlement after Tallman. A drawing of the Butters and Peters mill on the lakeshore supports this. Interestingly, the lake was not called Tallman at the time; 1884 plat maps show it as Grass Lake.

During the summer of 2018, Sandy Varnes of the Tallman Senior Citizen Center on Marshall Road and I were going through photo books and comparing the center's building with the old Tallman School. We concluded that it was not the school, as the map shows the school to be two short blocks up Maggie Street from Marshall Street. After leaving the center, I took a quick drive about the old village. Following Sandy's directions, I found the old school, which was right where the map said it should be and is today a home. I was surprised to find that the road named for the Butters family was narrow and unpaved—Marshall Street, named

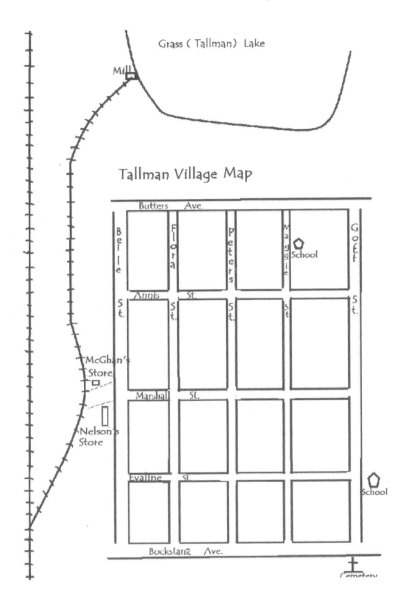

for the manager of the mill and Horace Butters's oldest son, is a two-lane paved road.

The Butters Mill at Tallman caught fire and burned in 1885. Although the company kept logging the area, Butters moved the remainder of his equipment and operations to the Buttersville mill, and the mill workers in Tallman lost their jobs.

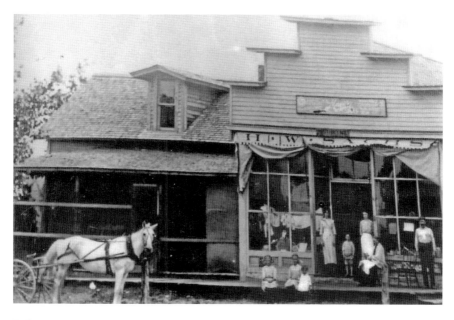

Tallman Village Store. *Courtesy of Tallman Senior Citizen Center.*

When Butters Mill was in full operation, the Flint & Pere Marquette Railroad added a spur from the main line to the mill at what is now known as Walhalla. At that time, it became known as Butter's Junction.

According to *The History of Mason County*, in 1882, when the tracks were extended to Manistee, Butter's Junction was renamed Manistee Junction. Around the turn of the century, Walhalla consisted of a train station, general store, post office and livery. The residents were calling it Merritt, but the post office was still Manistee Junction. In 1905, the post office was changed to Walhalla. In an article on Branch Township in *Mason Memories* (Winter 1980–81 issue), June Dereske states that Dr. Frederick Barothy Sr., who lived in Chicago, was the catalyst of the name change by creating a health resort for its "healing" mineral springs. One website says that Walhalla was the area's Indian name, meaning "haven for rest," but most sources adhere to the Dr. Barothy theory. (I won't argue with that, though I had guessed it was from the Norse word Valhalla.) As is often the case, change is hard: Mason County residents continued to call it Merritt until about 1909. Center School was in Walhalla, as well as Walhalla School, which was originally on the corner of U.S. 10 and Benson Road. It moved to First Street in 1918.

Camp Walhalla was a Civilian Conservation Corps camp on Taylor Road south of Walhalla. It closed in 1942.

Grass Lake (a different one) was south of Walhalla in Section 27 and is now called Casin Lake. Grass Lake School was located on the south side of Barothy Road. The community on Grass Lake is often called Grass Lake Settlement in county historical publications.

Just east of Walhalla on the north side of U.S. 10 is Emerson Lake. It hosted a very nice restaurant/lounge on the lakeshore. The post office was placed in a new hotel built by and named for the Nickles (Nichols) in 1880. Burt Barnhart purchased the hotel in the early 1900s and renamed it the Emerson House after the lake.

Branch Township supervisor Michael Shoup says, and early plat maps confirm, that Weldon Creek flows from Ward Hills, Lake County, into Emerson and Long Lakes and continues across Branch Township into Custer Township, where it ends in the Pere Marquette River. Readers might remember Ward Hills for being the location of after-school ski club trips.

Although it seems many of Branch Township's settlers were of German descent, Swedish Settlement straddled the county line about three miles north of Branch in 1895. It all began with a Stearns lumber camp (not related to Stearns Siding), where many of the workers were employed. When work was slow, they tried to farm. When the mill burned down and was not rebuilt, the loggers/farmers left the settlement because of the lack of job prospects.

Sweetwater School is just over the Lake County line in the Swedish Settlement, Sweetwater Township. Like many of Swedish ethnicity in Branch, Matt Stevensen settled in Sweetwater Township, Lake County, just over the county line from Mason County's Swedish Settlement. Like many other men in this area, he set up a farm and worked the rest of the time in the lumber camp. Unlike most of the lumbermen, he did not leave when Stearns Mill in Sweetwater burned down. He stayed, acquired a portable mill, and ran it down by the railroad tracks in Branch. He died in Sweetwater in 1945 at seventy-one years of age.

Comstock School was on the south side of Hansen Road about a mile from Benson Road on C. Comstock property.

Stearns Siding was east of Branch in Lake County. It was Justus Stearns's first mill in west Michigan. Stearns Siding had its own post office, named Bennet after Justus Stearns's clerk, who ran the post office. The Lake County Historic Society, in the Lake County Historical Museum, has photographs of an envelope from a letter Matt Stevenson sent to his sweetheart, Ingebord, in Sweden asking her to come to America to be his wife. She did, and they had four children. The postmark on the envelope is from Bennet.

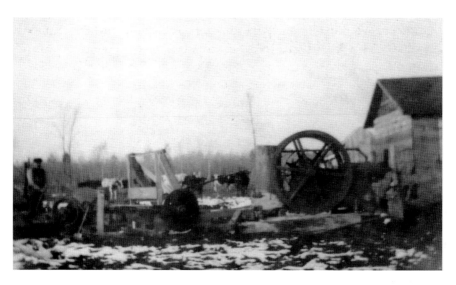

Matt Stevensen's portable sawmill, powered by a steam tractor, was located in Branch. *Courtesy of Lake County Historical Society.*

A final note on Walhalla and Branch is that for most of my life I have thought of Walhalla and Branch as villages, but Supervisor Shoup says they are settlements that never did become villages.

So, what is left in Branch Township? Sadly, not much. Most of the schools have merged with the Mason County Central (Scottville) or Mason County Eastern (Custer) School Districts. The settlements are just a shadow of their former selves. Tallman is left with the township's senior center and cemetery, although the 2012 plat map shows it as a village. There are no stores or businesses. It is a lake with houses scattered about it. Branch has little left but a post office with limited hours and a store. Gone are the Pepsi and asphalt plants, the gas station and the town tavern, the Oasis, which burned down and wasn't rebuilt. Walhalla has fared a bit better. The small family-run stores have been replaced by a Dollar General. Barothy Lodge, the place owned by Dr. Barothy (the source of the settlement's name), is still operating today along the Pere Marquette River. Piney Ridge and the Alpine Hotel (which was built by Supervisor Shoup's father) are still operating, and the Rendezvous Bar has a new life in Riley's Rendezvous Grill and Tavern. The Emerson Lake Inn has reopened at limited capacity. Unfortunately, in the reorganization of the U.S. Postal Service, Walhalla took a hit. The post office is still open but only part time, and there is no local delivery service. The mail carriers for the Walhalla area work out of the Branch Post Office.

# CUSTER TOWNSHIP

C uster Township separated from Eden Township in 1878. Much of Custer Township's history is tangled with the townships that surround it—Amber, Eden, Branch and Sherman. The history books tell us that the first settler came to the area in 1847.

The first town was founded along the Pere Marquette River by a man named Black and was called Black Creek after him. The creek begins north of U.S. 10 and drains into the Pere Marquette River (which was called the Black River, perhaps from the Indian name "River of the Black Robe"). The settlement of Black Creek was later called Ferryville, as the ferries delivered supplies, passengers and mail by river. E.M. Comstock was appointed Ferryville postmaster on September 1, 1875.

When the railroad came through, the settlement was moved up the hill closer to the tracks and renamed Custer after General George A. Custer. The post office was moved to the hotel on Madison Street on December 23, 1878. The village (see images on pages 40 and 41) had several grocery stores and a couple of meat markets, a hardware store and a barbershop. Supplied by local mills, Custer was the location of Brayman's Pin and Bowl Factory, which made clothespins, as well as a gristmill. Many of the old settlers claim that the pin factory was the largest in the world.

Custer Cemetery is actually four cemeteries in one. In a conversation with the Custer Township clerk Ann Larr, I learned that contrary to the beliefs of many, the Indian burial grounds are not along the river but a little farther inland. Stories tell that in the early days there were wooden slabs

# Custer Township

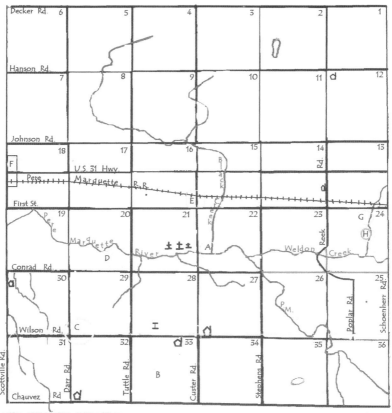

Custer Township Settlements

A. Black Creek
B. Indiantown
C. Wilson Corners
D. Herrickville
E. Custer
F. Sweetland - Mason Center - Scottville
G. Weldon Creek
H. Neilands Swamp (Possible)
I. Dunkard Settlement

d Custer Township Schools

Wilson School - Section 29 (moved to 30)
McClellan School - Section 12
Riverside School - Section 35
Menninger School - Section 5
Weldon Creek School - Section 13 (moved to 14)
Resseguie School - Section 27

✝ Custer Township Cemetery

Indian Burial Grounds - Section 21
Riverside Cemetery - Section 21
St. Mary's Catholic Cemetery - Section 21

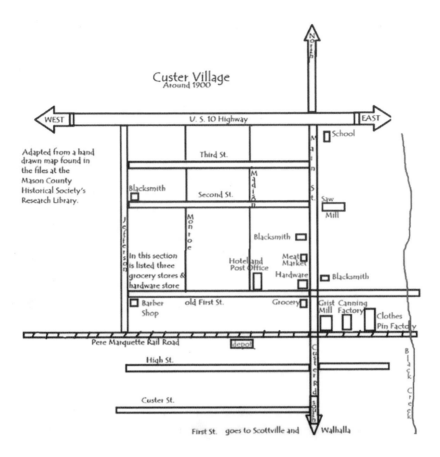

Custer Village
Around 1900

covering the graves. While a young child, I remember visiting the Indian Cemetery in Mikado in northeastern Michigan. Many of the graves had crosses made of small trees or wood. A house of unpainted wood covered the grave, and a small bowl or cup was placed beside the cross. My dad would leave pennies as an offering to the spirit. Offerings left in the bowls included stones, pennies, animal claws, teeth, or even cigarettes. The Old Custer Cemetery (settlers' graves) is along the river. The Native American family graves are nested within the Riverside Cemetery to the north of the last drive before the river. To the north of that are Riverside Cemetery graves up to a row of pines going east to west across the cemetery. St. Mary's Catholic Cemetery is on the other side of the trees in the northernmost part of the cemetery. The original road south of Custer ran along the west side of the cemeteries.

Indian Bridge is south of Custer along the Pere Marquette River to the east, where Reek Road crosses the river (see image on page 42).

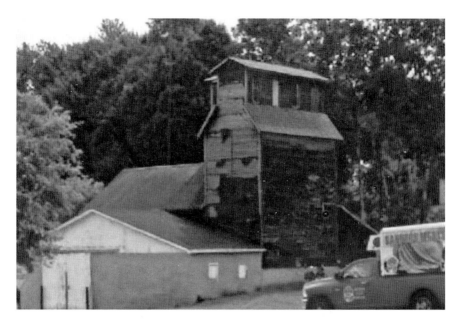

Custer Grist Mill, seen by the tracks from the north, is now Sanders Meats parking. *Author photograph.*

Custer Township was part of an Indian reservation created in 1856 that some called Indiantown. It was about a mile south of Custer and Scottville at Wilson Road and ran south through Eden Township into Oceana County's Crystal and Elbridge Townships. Much of this land was sold to white settlers, and eventually the reservation was no more. Records say that old Indian mounds were once visible when traveling on Custer Road south of Wilson Road, but farming and erosion brought them down some. One older resident pointed out that the mounds were north of Wilson Road and that the reservation ran to the river. Indiantown received a post office in 1865, with Samuel Hull as postmaster, which was closed in 1875, and their mail was then transferred in East Riverton.

Barton's Grove was south of Custer. The Barton family lived in Eden, according to *Historic Mason County* (1980).

The intersection of Wilson and Custer Roads was called Canada Corners, because the land owners on each corner were from Canada. This intersection was also called Wilson's Corners (because of the road) and Resseguie Corners (because of the school). Resseguie School (the Indian school) was built on Resseguie property at the northeast corner of the intersection in 1870. Several of the teachers were Native American former students.

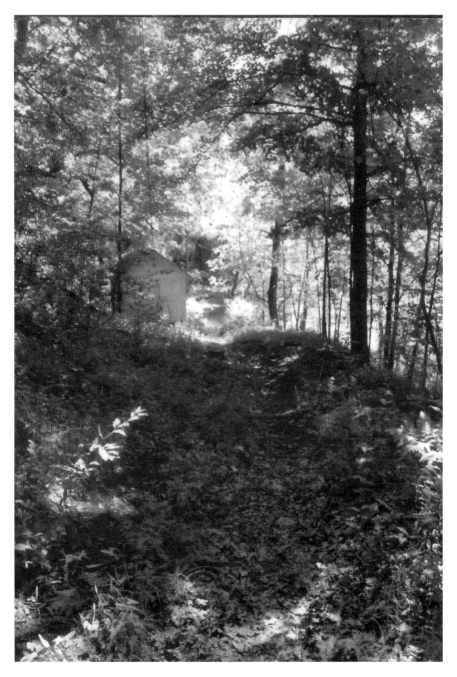

The path leading down to the river behind Custer Cemetery is thought to be the old road from the bridge to Custer. *Author photograph.*

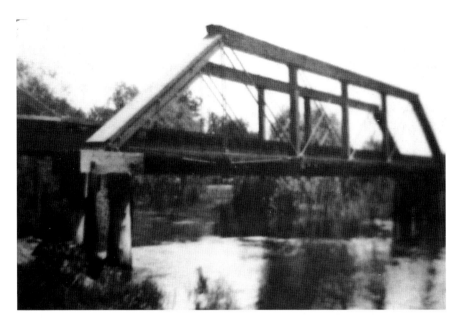

Old Bridge, over the Pere Marquette River, was west of the current bridge. *Courtesy of Ila Price-Smith.*

Herrickville, according to *Historic Mason County*, was a settlement founded by Fred and Frank Herrick on the southern bank of the Pere Marquette River south of Custer during the lumber days. The plat map shows it south of Scottville. Other sources state it was on the northern edge of Indiantown, which would take Indiantown up to the river. It had a store with a post office, mills owned by the Herrick brothers and a school.

Weldon Creek enters Custer Township from Branch Township near Section 24. It nearly reaches Reek Road and then flows west into the Pere Marquette River. The Weldon Creek settlement had a store, post office and its own school in 1905 on Reek Road south of U.S. 10 but north of the railroad tracks. It had its own station and was a stop on the Flint & Pere Marquette Railroad. The community may have moved west to Custer Village.

In his column in the *Ludington Daily News*, George Wilson mentions Neilan's Swamp, which may have been along the Pere Marquette River. Old plat maps suggest Neilan's Swamp was along the East Pere Marquette River (later called Weldon Creek) in Section 24, Custer Township, on Thomas Neilan's property (Neilan was a lumberman and had a mill). Another article on Custer mail carriers says that Neilan's Corner was two and a half miles

east of Custer and a half mile south of State Road (U.S. 10), which would put it in the same area. A map in *Historic No-ta-pe-ka-gon*, by Russell Anderson, shows Neilan's Marsh in the southeast corner of the township.

The Dunkard Settlement was a German Baptist settlement near the German Baptist church just off Wilson Road on Darr Road. The church was founded by Sugar Ridge church minister Shawn Keith's great-grandfather. The Dunkard faith followed Old World German beliefs. "Dunkard" came from the German word *tunk*, meaning to dunk, as in baptism. One death notice states that the Dunkards had a cemetery on Wilson Road near the church, but it is not on the old plat maps. Ron Wood, who owns property in the area, said he hadn't heard of it. He inquired with a minister of the faith (probably Shawn Keith), and he hadn't heard of it either. One would think Wood or his neighbors would have found headstones or uncovered some bones had the cemetery been there. When researching genealogy, you will find that newspapers, death certificates and cemetery stones are not always accurate. It is best to try to find other sources that say the same thing.

The Wilson School, built in 1905, was located on the north side of Wilson Road between Tuttle Road and Darr Road.

The city of Sweetland or Mason Center (Scottville) lies half in Custer Township and half in Amber Township. The Roach Canning Factory (later Stokely Plant) was in Custer Township, as was the old Carnation milk plant, which was on the north side of the railroad tracks south of the Mason County Central (MCC) School District bus garage.

Greenway Creek was mentioned in George Wilson's column also, but it's not exactly certain where it is. It might be in Section 17 or 18 of Custer Township, where Samuel Greenway and his son George owned property north of the Pere Marquette River. There is a creek in a ravine that crosses U.S. 10 between High and Elm Streets. The only map containing a creek is in the PDS (Print and Digital Solutions) phone book. It crosses the old S. Greenway property and flows to the Pere Marquette River. This is possibly the ravine between the city of Scottville and the old Stokely/mushroom plant.

Some early school districts in Custer Township are not mentioned above. McClellan School was in northern Custer Township, on the southwest corner of Reek Road and Hansen Road. Riverside School was southeast of Custer, on the south side of Wilson Road east of Custer Road near Reek Road, in the bend of the Pere Marquette River. Menninger School District was built in 1888 at the northwest corner of the intersection of Hansen and

Tuttle Roads. The schools in the township have consolidated into Mason County Eastern Schools. Some families that live on the border of another district had the choice of going to MCC.

Mason County Eastern Schools is the main employer in the township, and farming is the main industry. Sander's Meat Packing Company, the only business operating on South Main Street in Custer, is possibly the only slaughterhouse left in the county, when once upon a time Custer had two. A staple of my teen years, Johnny's Roller-Skating Rink and Sports Bar is still open, although the ever-famous Johnny and his wife, Maisie, are gone. There have been some recent rumblings of a possible statue or sculpture honoring the former mayor and business owner. Cranky's Small Engine Repair is located in the old Price's gas station. Wood N Things, a wood furniture store, and Johnson's Used Auto Sales are other businesses still operating in Custer. There are also two adult foster care homes and Great Lakes Auto Glass. Like other U.S. post offices in rural Mason County, Custer Post Office was reduced to operating part time, but it still has delivery.

# EDEN TOWNSHIP

Created from parts of Riverton and Amber Townships, Eden came into being in 1874 and included the land for the future Custer Township. In 1878, Custer broke off on its own. The first white settlers came in the 1870s, mostly Civil War veterans. An old plat map shows Eden Township as part of Riverton Township in 1873.

Originally created in 1855–56 as an Indian reservation that ran from Elbridge and Crystal Townships, Oceana County, up into Eden and Custer Townships, it was divided into parcels for Indian peoples in Grand Rapids, who had been forced from their original tribal lands farther south and east. One of the rules for receiving reservation land was that the Native Americans had to improve the land—clearing, building and raising crops—within five years. Having the land divided among them to live and farm like white men was not for the Native Americans, who continued to build their cabins in clusters on one plot of ground. Most sold their land to white settlers or just abandoned their claims (which were later sold to white settlers). Many moved north. One story is that a local farmer found a cluster of forty log cabins after purchasing old reservation property, while others found nothing built on theirs. Many articles written on Eden also called this area Indiantown.

The old reservation cemetery in Eden Township is on the south side of Major Road between Darr and Cabana Roads. As a child, I was told by the neighbor who owned the property that there used to be a Catholic church nearby to serve the Native Americans. An old essay in the historical society's files said that a group of Franciscans from the north bought the old Fern

# Eden Township

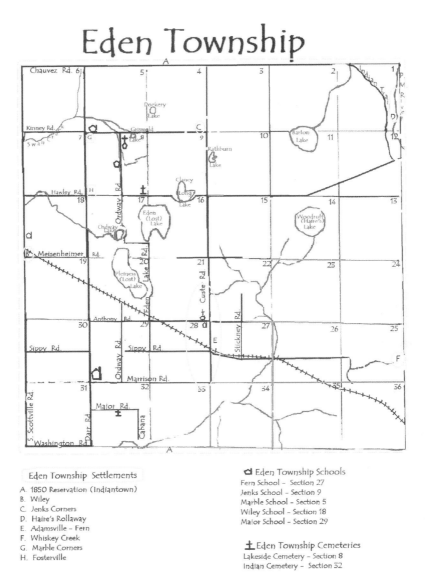

Eden Township Settlements

A. 1850 Reservation (Indiantown)
B. Wiley
C. Jenks Corners
D. Haire's Rollaway
E. Adamsville – Fern
F. Whiskey Creek
G. Marble Corners
H. Fosterville

Eden Township Schools
Fern School – Section 27
Jenks School – Section 9
Marble School – Section 5
Wiley School – Section 18
Major School – Section 29

Eden Township Cemeteries
Lakeside Cemetery – Section 8
Indian Cemetery – Section 32

school and turned it into a mission church for the reservation. The Indian cemetery was a few miles southwest of the church. After the Native American families left the area, the church was sold at auction. The diocese sold the cemetery land (which was a common practice) to a local farmer, who used it as a pasture. Thus, few gravestones—if there were many—survived, and some graves caved in.

The driveway to the Eden Indian Cemetery is overgrown, but just to the right of the drive, among lilac bushes, is a cement cross for Elizabeth Trombley, mother of Mary McDaquette. The cross was made by Mrs. Trombley's grandson Ernie McDaquette, who died in World War II and is buried in France. Several of his siblings who died in an epidemic are buried around her. The McDaquettes were one of the last Native American families on the old reservation.

With an abundance of freshwater lakes and forests, Eden was aptly named for the lumberman as well as the farmer. One of the first settlers was John Haire, a former Ottawa county legislator, who in 1873 settled on Haire's Lake. Upon his death, it was sold to Dr. Bertram Sippy and became Sippy Lake, and today, it is called Woodruff Lake. The still-private lake is south of Hawley Road east of Custer Road. In 2018, it was taken over by the American Legion as a recreation spot for disabled veterans.

John Haire came here to begin logging to recoup from a business loss in the southern part of the state. His lumber camp was in Section 1 (the northeast corner of the township) along the Pere Marquette River. There he created Haire's Rollway, an excellent sucker fishing spot today, but in lumbering days, it was where the logs were piled up on the riverbank to wait the winter until the ice melted. Then the logs were rolled into the river and floated away to the mill. Haire is also credited with building the first road in the township. It was a corduroy road, where logs were hewn flat on one side so they could lay side by side and dug into the path so the wheels of wagons could roll over it. This road ran from his lumber camp in Section 1 down to his other camp on Long (Clancy) Lake.

Hog's Back was another favorite fishing location along the Pere Marquette River. Both Hog's Back and Haire's Rollway were accessible by taking two tracks north off Hawley Road east of Custer Road. Today, the best way to reach it is from north off Indian Trail, as the two tracks, like our old settlements, are disappearing.

The 2012 plat book shows a small lake, Rathbun Lake, on the east side of Custer Road going north toward Custer between Hawley and Kinney Roads. It does not appear on the 1904 or 1915 plat maps. Though some may consider it a swamp, township supervisor Roger Nash confirmed that it is considered a lake.

Heading about a mile or so north, Jenks Corners is at the intersection of Custer and Kinney Roads. Jenks School is on the southwest corner. The Jenks family owned the land on the north side of Kinney Road in the 1904

plat book. To the east of Jenks Corners, Kinney Road ends at Barton's Lake, a private lake that years ago hosted a Boy Scout camp.

Heading west on Kinney Road and north on Tuttle Road, Dockery Lake is on the east side just before Chauvez Road. On the other side of the Kinney Road to the south is Griswold Lake, which is called Mobley Lake on the 2012 plat book. Both are on private property.

Marble Corners was at the northeast corner of Darr Road and Kinney Road. In 1881, E. Balch built a mill in this area. The 1884 map shows a post office near the school. Marble School District was the first school in the township. The original school was built in 1876. This building was moved to the northeast corner of Chauvez Road and became the grange hall; a new school building was built of brick in the same location in 1906. After the rural school became part of the MCC and Mason County Eastern (MCE) School Districts, the building was used as the Eden Township Hall. It is now a private home; a new hall was built on Hawley Road east of Custer Road.

Southwest of Griswold Lake and Marble Corners is Swan Creek, which flows west into Riverton Township to the Pere Marquette River. Near the head of Swan Creek in the southwest corner of Section 8 is where Fosterville once stood. A mill was erected there by the Foster brothers of Fountain; the creek was dammed up to provide water for the boilers. A small settlement of six homes developed on the northeast corner of Darr and Hawley Roads.

Southeast of Fosterville on Hawley Road near Custer Road is a cluster of lakes. Long Lake, now called Clancy Lake, was renamed when the government was trying to get rid of duplicate names in the county. On its eastern shore, John Haire put up a second mill, the logs hauled to Scottville by horses or oxen. On the west side was Camp Rakus, a summer camp for Lithuanian teens from Chicago. Although the camp was on Clancy Lake, the teens walked down the road to Devil's Lake to swim. Scottville-Custer and the surrounding rural area had many Lithuanian families.

Devil's Lake (today Eden Lake) is on private property to the southwest of Fosterville on the south side of Hawley Road. A hand-written paper at the Mason County Historical Society states that the Indians called it Devil's Lake because they believed an evil spirit in it drowned people. It is across the road from the township's Lakeside Cemetery. There is another old legend that someone once drowned in Lost Lake, and the body was found the next day in Devil's Lake. It's unclear if the lakes are connected, but we all believed it to be true and would say "The devil is up to his old tricks in Eden."

Just to the west of Eden Lake, on Ordway Road south of Hawley Road, is small Ordway Lake. Motorcycle races used to be held on the ice in the winter. I've been told there is some good crappie fishing there, but the water is dark with tannins and not pleasant to swim in. A good portion of the lake is right at the road's edge, so small boats and canoes can be launched. It does not have a maintained boat launch, and many try to put trailers in and get stuck.

Around the curves to the south is what locals still call Lost Lake (although on plat maps it is Pleiness Lake). The name was changed to Pleiness Lake after a local property owner in an attempt to get rid of duplicate names in the county. Arnold and Helen Nelson state in an essay on Eden Township that the Indians, who had an encampment on the east shore, called it Lost Lake because there were many drownings there and the bodies were never found. I know of a golf cart or two that was fished out of there after going through the ice (two of my canvas folding chairs were lost).

Lost Lake is the largest lake in the township. It does have a boat launch maintained by the Department of Natural Resources on its southern end (Lone Pine Road). A favorite fishing hole, every winter it becomes an ice fishing settlement of its own. The lake is the population center of the township today. It has many out-of-town property owners, and many local families live there year-round.

Across the road from Lost Lake in Section 21, Kline Lake is far off the road on private land. Today it is Stewart Lake, probably after Bruce Stewart's family, who owned the farm it was on. It is four or five times the size of Ordway Lake.

To the east side of the township is another old settlement, known as Wiley. Half of it lies in Riverton Township, with South Scottville Road the divide. The community was named for Lemuel Wiley, who lived just down Meisenheimer Road west of the store. In a letter to Rose Hawley, one resident states that Wiley was established after the Mason & Oceana (M&O) Railroad came through the area, but my impression is that Wiley was here first. Originally just a logging train, the M&O later added a passenger car on the back and would take people to Buttersville, where they caught a foot ferry across to Ludington. They would return in the afternoon on the five o'clock train. The M&O Railroad (owned by Butters and Peters Lumber and Salt Company) was a narrow-gauge railroad. (A narrow-gauge track is any track where the rails are less than the standard gauge of four feet, eight inches apart.)

The original Wiley Store and post office were north of the tracks on the east (Eden) side of Scottville Road. It was a station for the M&O Railroad

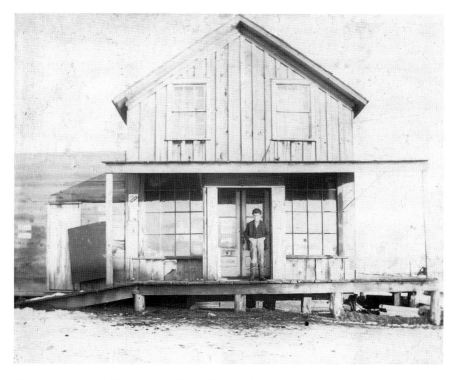

Wiley Store about 1900, owned by Jacob Harley, who moved it to the present location. *Courtesy of the Mason County Historical Society.*

and a boardinghouse. Around 1900, Jake Harley bought the store and moved it south to the corner of Scottville Road and Meisenheimer Road, where it sits today. In an essay in the files at the historical society's research library, Effie Bigsby, Jacob Harley's daughter, states that Jake also owned the original Riverton store on the corner of his father Isaac Harley's farm. His wife ran the Riverton Store, while he ran Wiley Store.

Paul Sherburn, longtime township supervisor, told his son David that when someone wanted to ride the train to Ludington, the store owner would hang a white flag out on the post and the train would stop and pick them up. The original feed mill was on the northwest corner of Scottville Road and Meisenheimer Road (Riverton Township). It was moved across to the southeast corner when the Rathbuns owned the store. Roach's Pea Vinery was less than a half-mile to the south of the store on the east side of the road by the creek (on the D. Sherburn property) that ran between the Sherburns' and the farm that would years later belong to my in-laws, the Malburgs. The vinery was removed, and the cook shack was moved to

the Sherburn farm for an extra building. Cement slabs are all that is left of the old vinery.

Wiley School, per the plat maps and longtime residents, was about a quarter-mile north of Wiley Store on the east side of Scottville Road. My mother-in-law attended Wiley School.

In her book on Fern, Viola Stickney states that Wiley School had the most students in the township. Of course, the children grew up, and the school was no longer needed. The few students left were sent to Riverton. David Sherburn, a lifetime Wiley resident, says the school closed and the building was auctioned to the man who owned an auto dealership in Scottville. He tore it down and used the wood to build a horse barn by his home. Also at Wiley were a creamery, a blacksmith and a mill. There was possibly a second vinery at Wiley, although where is unknown.

Built in 1879, the original Major School was a neighborhood project. Johannes Peterson donated the land, Alonzo Major the shingles and another man the logs, and a log cabin was built on the northeast corner of Darr Road at Marrison Road. A large yellow-brick school was built beside the original to hold the increase in students. The school was named for Alonzo Major, one of its benefactors. Sporting a bell tower, it was considered at its time one of the nicest schools in the county.

In an article in *Mason Memories* (spring 1976 issue), Don Dornbos shows an Indian school on the southwest corner of Section 29 (South Custer and Marrison Roads) on an Indiantown map. It's unclear if this was a mistake or if there was an actual school for the Indian children, like there was in Custer Township.

The largest settlement in Eden Township was Adamsville, where in 1879, Joe Adams built a lumber camp and mill at the southwest corner of Custer and Sippy Roads. Butters and Peters' Mason & Oceana Railroad built tracks through the area to get the lumber and logs from the settlement, which the railroad men called Long Siding. After lumbering days were over, the railroad pulled out. At this time, the township met to discuss changing the township's name. Mrs. John Haire came up with the name Fern for the fiddleheads that grew all over the valley, and so it was.

The original Fern School was built on the northeast corner of Sippy and Custer Roads; it was later moved to the southwest corner of Custer and Anthony Roads. The store–post office was at the railroad station north of the tracks that crossed the Custer–Sippy Road intersection diagonally, continuing out toward Whiskey Creek and Oceana County. Before the train, Fern Store was a stagecoach station. One coach ran to and from Crystal

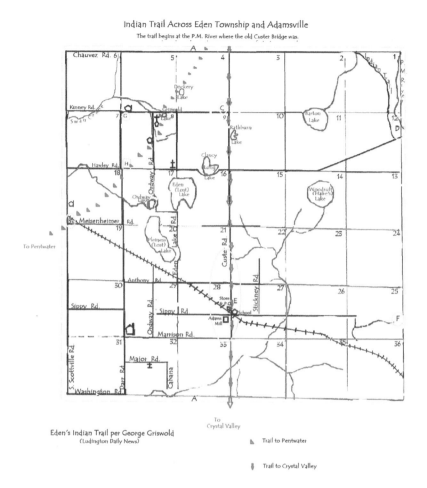

Indian Trail Across Eden Township and Adamsville
The trail begins at the P.M. River where the old Custer Bridge was.

Eden's Indian Trail per George Griswold
(Ludington Daily News)

To
Crystal Valley

Trail to Pentwater

Trail to Crystal Valley

Valley and another to and from Ludington. After the store–post office burned down around 1916, it was rebuilt a mile north on the southeast corner of Anthony and Custer Roads. The building was later turned into a home and is now gone. Plat maps show that the Fern settlement went from just north of Anthony Road down to the south of Sippy Road.

The original heart of Fern surrounded the intersection of Sippy and Custer Roads. Sippy Road was named for Dr. Bertram W. Sippy of Chicago, who owned property here and brought his family to the township every summer. Further east on Sippy Road is Sippy Swamp. Sippy Swamp was at one time considered one of the state's largest cedar swamps. It was originally called Pentwater Swamp (for the river) but was renamed when

Dr. Sippy bought it. In 1873, Dr. Sippy also bought Haire's lake property, which is where he died. He was buried in Chicago. Dr. Sippy was well-known in the Chicago medical society and was the creator of remedies for digestive disorders.

East of Sippy Swamp is Whiskey Creek. Whiskey Creek Settlement (which is divided between Mason and Oceana Counties) was given its name because it was said that whiskey flowed from the creek. The legend said that the saloon and store owner put in a stock of one barrel of whiskey at the beginning of winter, and during the winter, when the other settlements were running low, Whiskey Creek seemed to be gaining supply as if it ran from the creek. It was said that he had three barrels left after selling some to the other saloon and bar owners.

Some sources place the settlement of Woodburn in Eden, saying it was three miles south of Fern, and this would put it just over the county line in Crystal Township. An 1884 plat map shows the settlement between the county line and Crystal Valley. Finally, in a 1941 article on Fern, Hazel Stuart gives a story of how, in 1879, the Alf Carr family came from Ingham County in an immigrant wagon, probably pulled by an ox. They were stopped at the Pentwater River, as the damn downriver made it too deep to cross. The Carrs spent the night in Woodburn, and the next day, the keepers of the dam opened it so they could cross with their wagon and continue to settle in Fern.

Eden Township today has no industry other than farms. Fern Store closed long ago, and Wiley Store closed within the past decade. However, my son recently told me that Wiley Store has reopened. Whiskey Creek is still operating as a resort/condominium area.

# FREESOIL TOWNSHIP

One of the original three townships in the county in 1855, Freesoil contained all of Grant, Freesoil and Mead Townships. Grant Township was created in 1867 and Mead in 1910. Much of their early history is tied to Freesoil. It was founded by anti-slavery believers before the Civil War and was named to represent their beliefs.

Today, Freesoil Township is bounded by Grant Township to the west, Manistee County to the north, Mead Township to the east and Sherman Township to the south.

Mrs. E.M. Stephens wrote in an article that in the early days, the woods in Freesoil were so thick that pioneers had to "bark" trees (mark them) to find their way back and forth.

The first settlement was Old Freesoil, on Lake Michigan at Gurney Creek in northern Grant Township. According to an article in the *Ludington Daily News*, Pearl Darr states that the original settler was John H. Harris, who came in 1844 then sold the site to a man named Porter, who built the first mill in Mason County in 1845 (Mrs. E.M. Stephens states that Harris could have built the mill, as there is no record of Porter in the county before 1851). Porter's mill burned down in 1853, and it was rebuilt by Charles Freeman and his partner, a Mr. Hopkins, in 1855; they called it Freeman's Mill. Denton Gurney (or Gurnee) and his wife bought the mill and renamed it Gurney's Mill. This mill burned and was not rebuilt, and the workers moved inland and set up farms. The businesses followed to serve them.

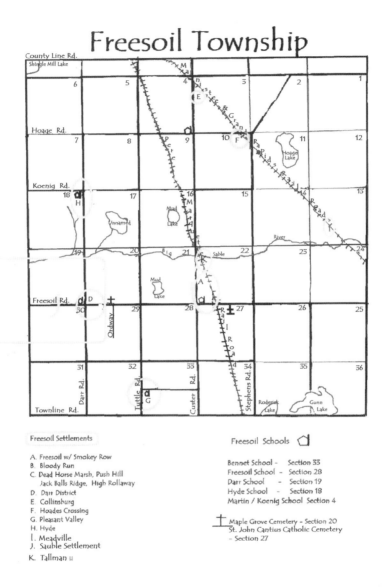

**Freesoil Township**

Freesoil Settlements

A. Freesoil w/ Smokey Row
B. Bloody Run
C. Dead Horse Marsh, Push Hill
   Jack Balls Ridge, High Rollaway
D. Darr District
E. Collinsburg
F. Hoades Crossing
G. Pleasant Valley
H. Hyde
I. Meadville
J. Sauble Settlement
K. Tallman u

Freesoil Schools

Bennet School -    Section 33
Freesoil School -  Section 28
Darr School    -   Section 19
Hyde School   -    Section 18
Martin / Koenig School Section 4

Maple Grove Cemetery - Section 20
St. John Cantius Catholic Cemetery
   - Section 27

New Freesoil (the village of Freesoil), on the west side of Sections 22 and 27 of the current Freesoil Township, dates back to 1860. The Flint & Pere Marquette Railroad tracks run on the east side of the village with a station stop. Smokey Row was a row of houses on the east side of the railroad tracks in the village just south of Bennet's Mill. Small subdivisions of the village were Oakwood Shores, Big Sable Acres and Cedar Shores. In 1872, Maple Grove Cemetery was created on Freesoil Road east of Darr Road.

St. John Cantius Catholic Cemetery is just east of Freesoil on Michigan Road behind the church.

The Big Sable River runs to the north of the village. Along the river east of Freesoil were areas lumbermen named Bloody Run, Dead Horse Marsh, Push Hill, Jack Balls Ridge, High Rollway, Keisels Cut and Rattlesnake Rollway. Obviously, these are terms of endearment for the places.

One paper, handwritten by a pioneer, described Bloody Run as a lumbering path that went downhill, across a creek and up a hill. Pulling a loaded "big wheel," the horses had to run down the hill while keeping ahead of the wheel, and the momentum kept them going through the creek and partway up the next hill. The essay said both men and horses died in the process.

The big wheel was the invention of Silas Overpack (blacksmith, wheelwright and carriage shop owner) of Manistee, created to help loggers to move logs in the woods. It was basically a heavy-duty axle with a huge wheel on each end. Logs were strapped beneath the axle by chains and pulled by a team of horses. At Mason County Resident Day at White Pine Village, a historian explained that the tongue the horses were attached to was very important to the big wheel, as if it was lowered, the load shifted forward a bit, and the load of logs would ride higher for traveling through the woods or uphill. When going downhill, it was raised, and the rear end of the logs would drag on the ground, thus slowing the rig.

After Grant became a township, the first Freesoil Township settlement was Sable Settlement (along the Big Sable River), which began at William Freeman's farm, two miles southwest of Pelton's Corners in Section 27 of Grant Township, and ran along the Sable River through Pelton and Darr Districts (where Freeman also owned property) all the way to Freesoil. The Sable Settlement had its own post office in William Tobey's store, which is said to have been near Freesoil Village in vintage *Ludington Daily News* articles.

One of the first schools was the Darr District, located on the southwest corner of Darr and Freesoil Roads. Built in 1866, Darr District was part of Sable Settlement, which ran from Section 26 in Grant Township to Pelton and up to Freesoil.

In 1870, the Freesoil Village School was built on Phillip Ritter's farm. Ritter was the first settler in Sable. Ritter's Swamp was west of his home.

H.C. Tallman bought a watermill on the south bank of the Big Sable River just north of Freesoil Village. He built a store and got a railroad depot brought in. He platted a village and sold lots and lumber for homes. The

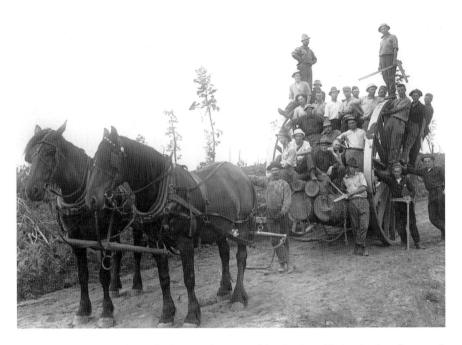

Michigan State University agriculture students on a big wheel used in lumbering. *Courtesy of Michigan State University Archives and Historical Collections.*

second Tallman village never became a popular spot, and the depot was abandoned by the railroad.

Three miles north of Freesoil was Collinsburg, which was built around a mill. There is no other information available. To the northeast of Freesoil is the settlement of Hyde, at the intersection of Koenig and Darr Roads in Section 18. The first settlers were William Blade and John Hoage. The Martin School was built on the southwest corner of Hoage and Custer Roads in 1888. Hyde School was built in 1881 on the southeast corner of Hoage and Darr Roads on the Herman Koenig property in Section 18. It was moved a mile east to the corner of Hoage Road and today's U.S. 31 in 1919, according to the history books. Hoage Lake is on the south side of Hoage Road west of Stephens Road. Hoades Crossing is along the Manistee & Grand Rapids Railroad crossing of Hoage Road near Stephens Road in Section 10. There is a school on the north side of the road on the Hoage property in Section 4.

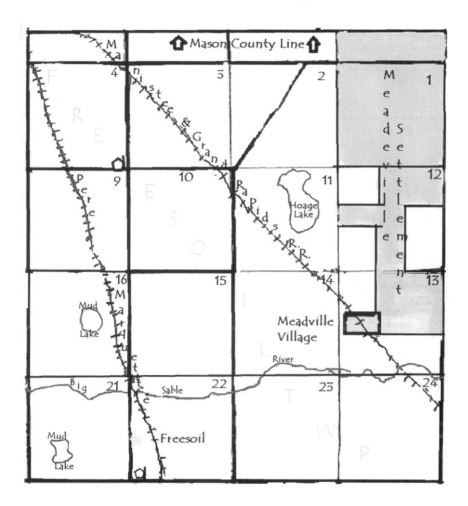

Luther Gunn set up a sawmill on Gunn Lake at the bottom of the township in Section 35 (the lower section of the lake is in Sherman Township). As with other mills, a small settlement grew. To the southwest of Gunn Lake in Section 35 is Roderick Lake.

On the east side of the township, Freeman Creek begins before Darr Road and crosses U.S. 31 flowing into Grant Township. It is named for William Freeman, who settled in Grant Township in 1863.

Pleasant Valley was created around Stearns Lumber Camp, just north of the township's southern border near Tuttle Road. Bennet School was built on the east side of Tuttle Road in 1901.

Common sense would say that Meadeville would be located in Meade Township, which is where most researchers look (including me). Some say

it was in Section 12 and near Elmton; another article says it is all of Meade Township (this is closest to the truth, but not it). The actual Meadeville village was placed in Freesoil Township.

Meadeville was east of Hoades Crossing and northeast of Freesoil. The community was created by George Swigert, who bought swampy land in Freesoil and Meade Townships at a very low price and sold it at top dollar, sight unseen, to unsuspecting buyers. The files at the historical society's research library contain an advertisement for Meadville that ran in out-of-town papers and on flyers and shows all of Sections 1, 2, 12 and 13 in Freesoil Township, with many lots scattered throughout much of Meade Township (I'm not sure if that should be considered Meadville, too, but the ad would lead you to believe so). At that time, Swigert was the largest landowner in Meade Township.

The actual village of Meadville was in Section 13 of Freesoil Township. The Manistee & Grand Rapids Railroad crosses through the village, which never grew. The ad claimed that "the lots were easily accessible from Manistee and Manistee Harbor." When the poor people arrived, they found swamps, quicksand and little farmable area. Access to their lots was anything but easy.

What is left in Freesoil Township today? A casual drive reveals only two businesses operating, including the Marathon gas station and E-Z Mart; all else seems vacant or in private use. Stopping at the post office, one can gaze on the closed Old Freesoil School in the background. At the post office, U.S. postman Tom Leonard says that the school gymnasium is now being used for the Freesoil Senior Center two days a week. Unfortunately, like Walhalla, the Freesoil Post Office is open four hours a day with no mail delivery. He said those with a Freesoil address have their mail delivered out of the Fountain office. Additionally, four churches are still going, which tells of their importance to their community.

# GRANT TOWNSHIP

**N**amed after General Ulysses S. Grant, Grant Township was formed from part of Freesoil Township in 1867. Although it was a new township, it had functioning settlements at its birth. By this time, future state legislator Charles Mears owned most of the property along Lake Michigan up to Old Freesoil.

Previously called Porter Mills, Gurneytown, Gurnee or Gurney, Gurney Mills, Freesoil Mills or just Mill Town, Old Freesoil was the first settlement formed in Grant Township. It was located at the mouth of Gurney Creek on Lake Michigan. By 1916, the dam, pond and piers that projected out into Lake Michigan were the only proof of the mill left. According to Hannah Bittel in a *Ludington Daily News* article, John Harris bought thirty-seven acres in Old Freesoil.

Old Freesoil School was located a couple miles east in Section 4, at the northeast corner of Sass and Morton Roads.

Some sources spell the settlement's name "Gurnee," but it is here spelled with a *y* as on the maps and road signs. Gurnee and Gurney Creek were named for Denton Gurnee/Gurney, the last mill owner. (U.S. census documents use both spellings.) Gurney Creek begins near LaSalle/Quarter Line Road area (Section 3) and flows west to Section 6 at Lake Michigan.

To the south of Gurney Creek is Cooper Creek (it does not show up in early plat maps), which begins in Section 18 and flows to Lake Michigan in Section 13 (which is beside 18). You might be wondering why Grant Township has such an odd section layout. Counties were platted out in

## Grant Township

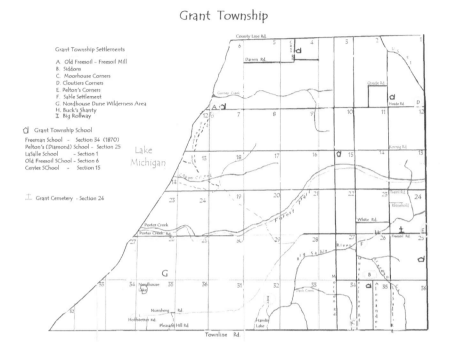

Grant Township Settlements

A. Old Freesoil - Freesoil Mill
B. Siddons
C. Moorhouse Corners
D. Cloutiers Corners
E. Pelton's Corners
F. Sable Settlement
G. Nordhouse Dune Wilderness Area
H. Buck's Shanty
I. Big Rollway

Grant Township School

Freeman School  -  Section 34 (1870)
Pelton's (Diamond) School - Section 25
LaSalle School    - Section 1
Old Freesoil SChool - Section 6
Center SChool    -   Section 15

Grant Cemetery - Section 24

blocks of thirty-six sections. If a township is oddly shaped or large, as is the case here, the numbering of the sections seems a bit off, but if you lay them out in blocks of thirty-six side by side, it makes sense.

Porter Creek begins in Section 24 and flows to Lake Michigan in Section 23. Porter House, a halfway house, was located at the mouth of Porter Creek. James Porter bought one hundred acres there in 1851 (which is probably the record Mrs. Stephens is referring to above; see chapter 5.). It is thought that Charles Mears had a lumber camp there. Along the bottom of the township, Davis Creek flows from Section 35 west until it joins the Sable River.

Big Rollway was on the northeastern shores of Hamlin Lake in Section 32. This is about the area of Mear's Middle Shanty Lumber Camp.

Buck Shanty was one of Mear's logging camps on the Big Sable River, where the river crosses Section 23 and 26 on the east side of the county. Buck Rollway was a small, steep rollway, unlike most others.

North of Davis Creek was the settlement of Siddons, in Section 26 and 35 around the Freeman and Alexander Road area, per the 1882 plat map. Diamond School District was located at Siddons, as was a post office. The Mason County Historical Society's Historic White Pine Village has a log

cabin labeled as the "Siddon Print Shop." The building was originally the Siddons Post Office. The village states that the post office was located on Townline Road, which is possible, but it also says that the post office was built in 1862 on William Freeman's property that he bought from Charles Mears. According to the plat maps and history articles, Freeman's property was farther north near Freeman Road and Freeman Creek. The 1882 plat map shows the post office on Freeman Road, as well. It may have been relocated or moved. The plat map and the community columns in the newspaper archives referred to the settlement as Siddons. Even the U.S. postmaster appointments list it as Siddons in 1882.

Sable Settlement began at William Freeman's farm, two miles southwest of Pelton's Corners in Section 26, and ran along the Sable River through Pelton and Darr Districts (where he also owned property) all the way to Freesoil. The Sable Settlement had its own post office in William Tobey's store. (Sable Settlement and River should not be confused with Au Sable Settlement and Au Sable River, which are across the state by Oscoda.)

Nordhouse Lake is in the northwest corner of Section 35. It is said that in the heat of the summer, Nordhouse Lake will occasionally dry up. Nordhouse Wilderness Area is north of Hamlin Lake in Grant Township.

Siddons Post Office, built in 1860 by William Freeman, is on exhibit at White Pine Village as Siddons Print Shop. *Author photograph.*

Siddons Post Office was William Freeman's family home. *Courtesy of Mason County Historical Society.*

The Nordhouse area is probably named for Albert Nordhouse, a farmer and Civil War veteran. He lived in the county for fifty-five years before moving at eighty-one years of age to Port Huron in 1915 to live with his daughter or son.

Moorhouse Corners was in the area of Townline and Quarterline Roads near property owned by Frank Moorehouse.

To the east side of the township, where today's U.S. 31 runs between Freeman and Freesoil Roads, is Pelton's Corners, named for David C.

Pelton. It is possible that at one time there was a road branching off to the west between Freeman and Freesoil Roads, but the intersection might have been Freesoil Road and U.S. 31 (the Orchard Market area). Pelton's School was on the Grant side of 31.

Articles in the *Ludington Daily News* in 1916, 1919 and 1936 point to the location of Cloutier's Corners as being near Pelton's Corners around U.S. 31 and Koenig Road. J.B. Cloutier owned a store there.

In 1870, Freeman School was at the southwest corner of Freeman and Quarterline Roads. LaSalle School was at the corner of LaSalle and Hoage Roads. Flynn School District, mentioned in a 1916 *Ludington Daily News* article, was at the Grant/Filer (Manistee County) township line. Old maps do not show it in Grant Township. However, neighboring children in Grant Township attended it.

Old Mail Road was a plank road that allowed mail and goods to travel from Old Freesoil to Charles Mear's home in Lincoln. Per *Mason Memories*, it also ran from Old Freesoil to Manistee. Reportedly the road was set inland, away from the shore.

Grant suffered the loss of its lumber mills and camps, which employed many. When these burned or the industry declined, people moved away. Today, I can only think of one business—Doc's Sable River Inn—left in the township. The plat map shows that about 30 percent of the property is taken up by the state and federal governments. This has now become part of the Lake Michigan Campgrounds and Nordhouse Dunes Wilderness Area.

# HAMLIN TOWNSHIP

C reated in 1860 by the county board, the original township was bordered by Lincoln to the south, Lake County to the east, Freesoil to the north and Lake Michigan to the west. Today it is surrounded by Pere Marquette to the south, Victory to the east, Grant to the north and Lake Michigan to the west.

Big Sable/Sauble (Hamlin) Village began as Charles Mears's North Mill (Big Sable Mill), and as will happen in this county, a settlement grew around it. A year later, the name was changed to Hamlin after the sitting vice president, Hannibal Hamlin, with whom Mears was impressed. It was located at the mouth of the Sable River at the current Ludington State Park.

A *Ludington Daily News* article written by Mrs. Frank Beaune in 1941 states that the original mouth of the Sable River was north of Point Sable but that a dam there washed out right away, and Mears redirected the river to its current position. This is supported by George Egbert, whose mother was the first child born in Hamlin Village (see image on page 70). In a 1956 article in the *Ludington Daily News*, he said:

> *Before Mears started his improvements at the site, the river had a different course (quoting Will Campbell, Hamlin Village Resident) than it does now, veering north from a point where the state highway bridge now is as far as the Coast Guard Station where it emptied into Lake Michigan. The river was then relocated to its present location and a new dam was built, the thought being that it was less apt to wash out. A section of the road to the lighthouse (Point Sable) follows the old riverbed.*

## Hamlin Township

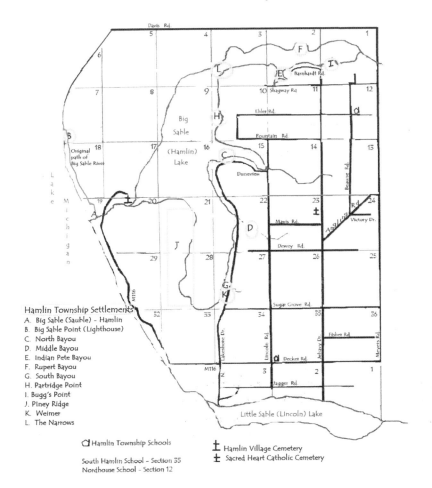

Hamlin Township Settlements
A. Big Sable (Sauble) - Hamlin
B. Big Sable Point (Lighthouse)
C. North Bayou
D. Middle Bayou
E. Indian Pete Bayou
F. Rupert Bayou
G. South Bayou
H. Partridge Point
I. Bugg's Point
J. Piney Ridge
K. Weimer
L. The Narrows

◻ Hamlin Township Schools

South Hamlin School - Section 35
Nordhouse School - Section 12

☨ Hamlin Village Cemetery
☨ Sacred Heart Catholic Cemetery

As was common in those days, the post office was located in the company store, which was at Lower Sable (Hamlin) Village on the south side of the river's mouth. Here also stood a sawmill, a boardinghouse and mill worker homes. To the east of the mill was a covered bridge connecting the north and south sides of the river. On the north side was the lathe mill and a pier at which scows (flat-bottomed boats) were loaded to haul lumber to schooners anchored offshore (another pier stood off the south side of the river as well). A track ran from the north pier east to the shingle mill at Upper Hamlin Village beside the dam. A wagon trolley was pulled along the track by mules

Hamlin Village after the dam broke in 1888. *Courtesy of Mason County Historical Society.*

from the shingle mill to the pier, where the shingles were loaded on a scow. North of the dam and river were about forty buildings, including stores, mills, another boardinghouse and twenty shanties with outhouses where the workers and their families lived.

In 1888, the dam failed, and the entire village, mills and a million feet of logs were washed out into Lake Michigan. Along the way, the logs crashed into the buildings, smashing them to pieces. The wreckage was strewn from Point Sable to Frankfort. The mills and village were not rebuilt.

Due to its location, "several hundred feet north of the old dam" on the wooded hill, the Hamlin Cemetery was untouched by the dam failure. In a 1956 *Ludington Daily News* article, George Egbert goes on to say that there were about fifty people interred in that cemetery. Visitors to the state park speak from time to time of finding gravestones there. Sadly, the park interpreter told me that the old cemetery had been vandalized years ago. Stones were pulled out, broken and moved. Not knowing where the stones went originally, the ones that were whole were placed in the ground. They are no longer on the actual grave, but the graves are still nearby.

Farther east of the cemetery, on Big Sable Lake, was the *Mud Hen*, which was described as a scow with a steam-powered sidewheel. Some maps show another mill beside the newer dam.

Big Sable—or Sauble Point—Lighthouse was built in 1867 north of the Sable River in Section 7. It contained a life-saving station (an early coast guard station) beginning in 1875. Big Sable/Sauble River flows across the county from Round Lake to Hamlin Lake on Lake Michigan. Hamlin Lake (formerly Sable Lake) was created when Mears built the dam on the Sable

River. This dam washed out in 1888 but was rebuilt with the river rerouted to its new location. The dam washed out again in 1912. It was rebuilt and is there today.

Old Mail Road was a plank road that carried mail and supplies through Hamlin Township. Hamlin Lake, east of Lake Michigan and Hamlin Settlement, comprises most of Hamlin Township. North Bayou in Hamlin Lake is in Section 15 off Dune View Road west of Lincoln Road. Middle Bayou is in Section 22 off Dewey Road west of Lincoln Road. East of Middle Bayou, on the east side of Jebavy Drive north of Angling Road, is Sacred Heart Catholic Cemetery (Hamlin Indian Cemetery).

Indian Pete's Bayou in Hamlin Lake is named for Ottawa Indian Peter Espiew, who owned land around the bayou and lived there. It is in Section 2 off Shagway and Lincoln Roads. Indian Pete has become a legendary figure whose reality has been disputed by some, while others insist they personally knew him and were present at his death in Brethren, Manistee County. His death certificate says he was born in Hamlin around 1830 and died in 1925 in Brown City, Manistee County.

Other popular features on Hamlin Lake include Rupert's Bayou, on the north shore across from Indian Pete's Bayou. South Bayou is in Section 27 on the eastern shore along North Lakeshore Drive north of Sugar Grove Road. The Narrows are in Sections 3 and 4 where the shore expands to leave a narrow waterway to the other end of the lake. Bugg's Point, a resort in the middle of Section 2 on old maps, is on Jebavy Drive north of Barnhart Road. It originally was called Middle Shanty and was Charles Mears's second mill settlement on Hamlin Lake. Piney Ridge is on the southwest shore of the lake. It was first owned by William Hudson. A hotel called Hudson Bay burned and was never rebuilt. Eventually, the state bought much of the property, and that land is now part of the state park. Weimer is a settlement in Section 27 on North Lakeshore Drive between South Bayou and Dewey Road. Kitty Creek is on the lakeshore six miles north of Point Sable, which would place it in Grant Township.

South Hamlin School was in the Lincoln Settlement at the corner of Decker and Lincoln Roads. It is listed here as it taught Hamlin children as well as children from Lincoln. Nordhouse School District was on the northwest corner of Fountain Road and Jebavy Drive. It covered the northern half of the township.

Hamlin is no longer an industrial area, nor does it employ hundreds of people. Gone are the mills that supported the families of the area. A different and stronger dam is in place in Ludington State Park, which now

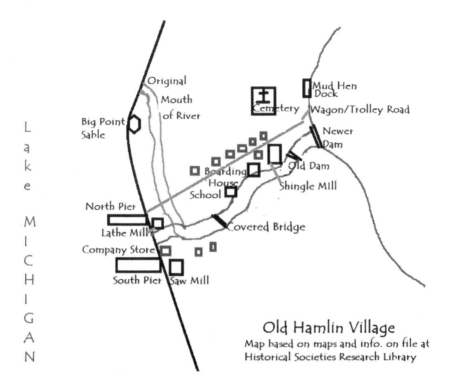

**Old Hamlin Village**

Map based on maps and info. on file at
Historical Societies Research Library

lies where the old Hamlin Village was. Hamlin, with its lakes and dunes, became a much sought-out resort area. Its population grows exponentially in the summer. There are still homes and local residents, but most of the businesses are geared for tourism. There is a fishing tournament held on the lake each winter, when the lake becomes a small shanty town again.

# LINCOLN TOWNSHIP

L incoln Township was one of the original three townships created in 1855 (along with Freesoil and Pere Marquette). An article in *Mason Memories* (Spring 1978 issue) states that Lincoln Township was completely owned by Senator Charles Mears. It extended from Lake Michigan eastward along Black Creek (also known as the Little Sable or Lincoln River) and was bordered by Hamlin and Victory on the north, Amber on the east and Pere Marquette to the south.

Born in the state of Massachusetts, Mears was the son of a lumberman and canal owner with a lock. This experience would come in handy for Charles in the future. He and his siblings were orphaned when young, and their guardian sent them away to school to finish their education. After school, he and brother E. Mears worked near home until after their sister married. Then the brothers bought up a bunch of merchandise and moved to Paw Paw, Michigan, where they opened a store, E.&C. Mears Company. They stocked anything they thought a person would buy, and in spite of hard times, the business prospered. After being joined by their younger brother, they chose to move north. They explored the west Michigan coast as far as Manistee and then settled in Whitehall. Charles built his first mill at Duck Lake in 1837. Around 1847, he purchased most of the land along the shoreline of Mason County north of Pere Marquette Village.

Mears's South Mill was built at Black Creek (Lincoln River) in 1849–50, and the settlement grew around it. The North Mill was built around 1854 at Big Sable. In 1855, the county was organized; the Hamlin area was called Big Sable, and the Lincoln area was called Little Sable.

## Lincoln Township

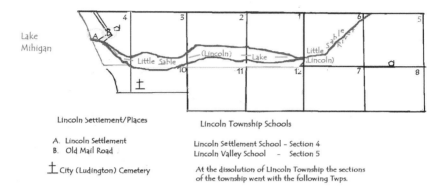

Lincoln Settlement/Places

A. Lincoln Settlement
B. Old Mail Road

⊥ City (Ludington) Cemetery

Lincoln Township Schools

Lincoln Settlement School - Section 4
Lincoln Valley School    -    Section 5

At the dissolution of Lincoln Township the sections
of the township went with the following Twps.

Per the historical society, with his experience in lumbering and canal building as a boy, he set about building the dam on the Little Sable River in 1850. Little Sable (Lincoln) Lake was made. Mears constructed a channel and harbor, which he had dredged so large ships could enter and tie up at the dock by the mill. In Hamlin, the lumber had to be hauled to the ships anchored offshore.

In 1860, he leased the mill at Pere Marquette Village from James Ludington (at no cost, Paul S. Peterson tells us in his book on Ludington). Seeing the need for a better harbor, it is suggested that he worked with Ludington to get permission from the government to move the harbor. Once received, it took him and his crew three days to accomplish the task (although it took nearly a year to completely close off the old channel at the foot of Clay Banks).

Mears had dreams of Sable becoming the largest city on the west Michigan coast, and he set about to make it so. First, he needed to make it the county seat to get control over the county. In *Mason Memories*, the author hints that Mears tried to gain votes to move the county seat by employing the voters and having them live at his settlements. He failed in 1855, so he hired more supporters (employees), and in 1859, he won the election, and the county seat was moved from Burr Caswell's home in Pere Marquette Village to Big Sable.

In 1860, Mears attended the Republican Convention in Chicago. He donated all the evergreen and pine boughs (three boatloads per his journal) from Mason County to decorate the "huge" wigwam in which the convention was held. He was so taken with Abraham Lincoln and Hannibal Hamlin that he labored to help them get elected. He was also bitten by the political bug.

Having over five hundred residents, the settlement included homes, stores and even a school. Mears was elected (with his voters' help) to the senate in 1861. He also set about renaming the Sables after President Lincoln. The village was also called Abe Lincoln Town. After that, Mears made his home in Chicago, and his settlements and mills were run by overseers.

In 1870, the amount of standing timber left in the county was much lessened, although still profitable. Mears sold the mill and lands to Pardee, Cook and Company, who built new dwellings by 1872. By 1880, the population was down from 500 to less than 150 people, and by 1884, the last mill store was closed. The lumber era was over, and Lincoln was abandoned. By 1895, all that was left was empty buildings. An article said that the large boardinghouse had a dune growing around it that covered the lower windows. Lincoln, with its four mills, boardinghouse, homes for workers and families, school and docks, was silent. Boats sat half covered in sand on the former shores. No one except the bones in the small cemetery on the hill were left, and Lincoln Township was dissolved in 1891.

And then came Epworth! The hills echoed with life and laughter again.

In much of the press about Charles Mears, he comes off as a stubborn, arrogant, greedy man who would do nearly anything to get what he wanted. He probably was, but there is another side to the man. Articles written by his employees and their families portray a caring and helpful man who would

## Lincoln Settlement

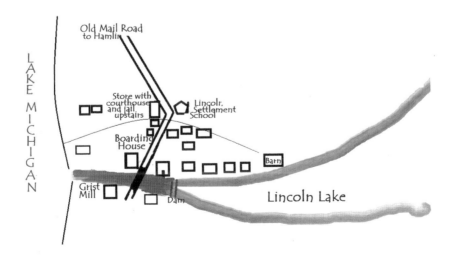

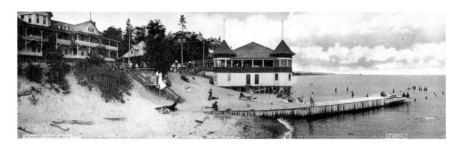

Following the end of Lincoln, the area was revitalized with the birth of Epworth Heights. *Library of Congress.*

stop to visit the sick or grieving and made sure people had what they needed to survive—a man who some thought of as a "god" (although a bit of a penny pincher).

Did he do what he did in Mason County out of ego and greed or to help his community? Probably at first it was greed and ego. Hiring people to gain their votes isn't good, neither was moving the channel away from the Clay Banks so he could build a harbor to ship his lumber, but we need to consider the fact that the man was responsible for two Mason County communities full of people. Five hundred employees at Lincoln alone and their families relied upon him, and he had Hamlin also to think about. It makes me wonder what others might do in his situation. His reasoning and tactics were very flawed, but the city of Ludington would not be here had he not moved that channel from Buttersville. There would be no harbor, no car ferries and no Dow, or many of us.

# LOGAN TOWNSHIP

Logan Township's history is tied to that of other townships in the county. In 1868, it was part of Riverton Township. When Branch Township was formed in 1871, Logan became part of it. It seceded from Branch Township in 1903. Past history books stated that the township was possibly named after Civil War general John "Black Jack" E. Logan, who served in the Battles of Pea Hill and Blakely (he was also an 1884 vice presidential candidate). As most of the early settlers fought in the Civil War, it is likely they chose him for his heroic service in that war.

Rich in lumber and home to the Pere Marquette River and tributaries, Logan was a prize location for Mason County's hardy settlers. However, unlike other townships in the county, there is no railroad, and many of the main families came before the lumber camps and mills. Once the camps and mills were established, more people followed. Supposedly, in the lumber days, many of the trees had a five-foot diameter. Michigan Tech University in Houghton estimated these trees to be approximately three hundred years old.

The township's largest community, Carr Settlement, might be considered to be made up of smaller settlements. It is on the Mason/Lake County line and centered on Hawley and Tyndall Roads. It was originally called McCumber Settlement after one of the original three settlers: Ben Bennet, Charles Carr and Ed McCumber. Ed McCumber settled in Section 24, and his children later settled in Section 23.

Township supervisor Bruce Burke remembers being told that there was a log school on Deren Road just a half-mile east of Masten, but nothing

## Logan Township

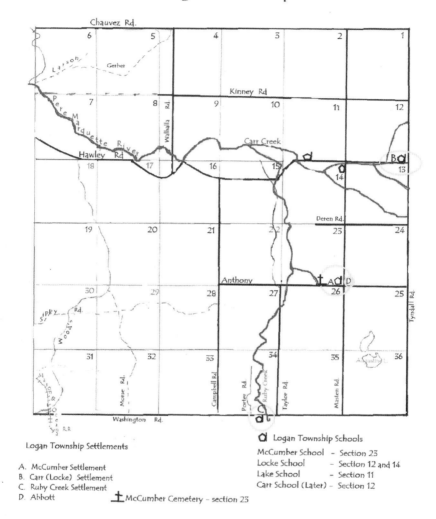

Logan Township Settlements

A. McCumber Settlement
B. Carr (Locke) Settlement
C. Ruby Creek Settlement
D. Abbott

✝ McCumber Cemetery - section 23

⌂ Logan Township Schools

McCumber School  - Section 23
Locke School      - Section 12 and 14
Lake School       - Section 11
Carr School (Later) - Section 12

was left but a slab in his day. This would have been on the Ed McCumber property and the first school in the township. The McCumber School, located in Section 24, was later rebuilt at Anthony and Masten Roads. It became the town hall when the schools consolidated.

McCumber Cemetery, the township's only cemetery, is just to the west of the new school on Anthony Road. Across the road from the cemetery was

the old Burke property, on which once stood a lumber camp. An interesting 1945 *Ludington Daily News* article written by Pearl Darr says that a photograph of a hemlock stump on the Burke property shows the stump to be six feet in diameter and twenty feet in circumference.

The original post office, Abbot Post Office, was located in 1868 in the home of William Perring in the McCumber Settlement in Section 24, which leads one to believe the settlement was at one time called Abbott. The 1904 plat maps show William Perring living at the northeast corner of Anthony and Masten Roads. At that time, the post office was farther east, at the northwest corner of Hawley and Tyndall Roads at Burman's General Store, which remained after the area was named Carr. Carr Store has had many owners and keepers and was probably the location of the Carr telephone office, originally owned by W.H. Buffenbarger and C.M. Locke. In its heyday, Carr Settlement also had several mills (including Masten and Lyon's Mills).

It seems many of the residents came from Indiana, thus the area was also nicknamed "Little Indiana."

In a 1923 *Ludington Daily News* article on Carr Settlement written by eighth grader Luella McCumber, she says that the first road was cut by Ed McCumber and William Perring so they could haul stuff with their team of oxen. Until then, the route to Pentwater for supplies was old Indian trails that they had to walk.

Locke Settlement, also in the Carr area, was named for Levi Locke. Locke School was originally built at the corner of Hawley and Tyndall Roads per the county history, but handwritten histories don't show this. Instead, they claim that Locke School was originally built on the Lewis Lake farm, on the north side of Hawley Road between Taylor and Masten Roads. Some people thought it should be Lake School, as it was on Lake's property and he was an early benefactor to the school. In 1908, it was moved across the road to the southwest corner of Hawley and Masten Roads, just south of Carr Creek (see image on page 79). With dwindling lumber, families moved, and with fewer children in the area, other schools consolidated with Locke School. The children were transported by horse-drawn wagons to school each day. Later, this school consolidated with Ruby Creek, creating the Carr School District, the main school in the area.

It was a bit unclear where Locke Settlement fit in here, and the final word was given to Betty Johnston, Carr Settlement historian, early Lake County Historical Society supporter and former Carr resident. She said that some people (mostly Mason County residents) called the area Carr

Slice of pine tree along Kinney Road. The diameter of the pine tree that stump is leaning on is over one foot. Lumbermen cut much larger. *Author photograph.*

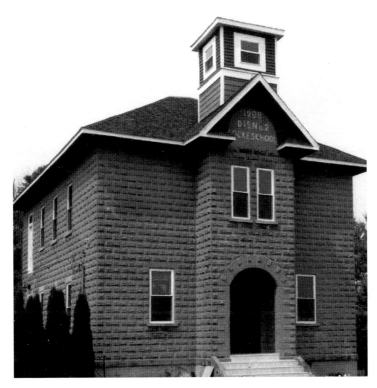

*Left*: The second Locke School, pictured in 2018. *Author photograph.*

*Below*: Construction of the second Locke School in 1908. The original was across the road. *Courtesy of Tammy Bromley.*

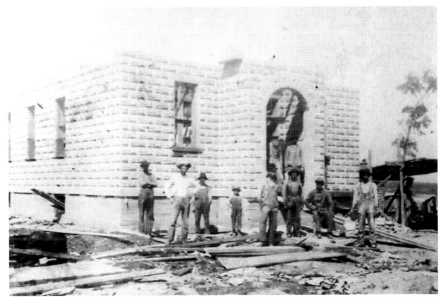

Settlement, and the people of Lake County called it Locke Settlement. Lewis Locke owned property on both sides of the county line.

Should you look up an ancestor in an area cemetery on the Find a Grave website, the odds are that the memorial for that person was created by Betty Johnston. She walked all the cemeteries in this and neighboring counties copying down the information on the gravestones and created memorials for each one to help families with their genealogy research.

A hand-written memoir at the historical society states that Wingleton was the name of the post office at Searns Siding. Bruce Budzinski of the Lake County Historical Society says Wingleton is actually a few miles east of Carr Settlement and was named for Mr. Wing, a resident. He showed me the Wingleton postmark, which means it had a post office. Wingleton was the junction for the Flint & Pere Marquette Railroad and the terminus for the Lake County Railroad, owned by T.R. Lyon of Ludington. There is also a Wingleton Road that runs east of Branch before the railroad tracks. Bruce Burke, township supervisor, said that there had been a small Swedish settlement east of Lake/Locke School. No other information could be found, but some of the descendants of these families remain in the township.

At the Lake County Historical Museum, there is a flat-bottom river boat that was only used on the Pere Marquette River as far as anyone knows. This boat was made near Carr Settlement east of the county line in Lake County. It was created by Walter MacDougall, who settled in the area with his wife, Giselle, and built MacDougall Lodge on the Pere Marquette River banks. By 1910, they were making wooden boats. MacDougall boats were sixteen feet long, flat-bottomed and square-ended, made of pine and propelled by a sixteen-foot elm pole. The MacDougalls used the boats to guide fishermen on the Pere Marquette River. They were made by Walter MacDougall, his sons Gordon and Thomas and William Behrens.

The township's other main settlement was Ruby Creek, which lies on its southern border and is divided between Mason and Oceana County at Washington and Porter Roads in Section 34. The settlement's post office is across the road from the store in Oceana County, as was Ruby Creek's little red schoolhouse, built in 1903.

In *Mason Memories* (fall 1975 issue), Mrs. H. Bartlett, a former resident of Ruby Creek, states that it is thought the settlement was named for Dr. George Roby, owner of a lumber camp in the area and Ludington's fourth mill. The mill is on the south side of Pere Marquette Lake, which is fed by the Pere Marquette River, which is fed by Ruby Creek. Mrs. Alva Kirkman,

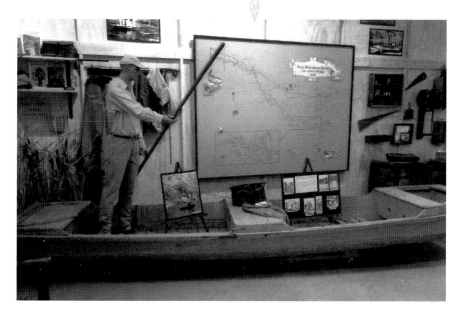

A MacDougall boat on display at Lake County Historical Museum. These boats, built east of Carr Settlement, were only used on Pere Marquette River. In the back right are the workbench and tools William Behrens used in making the boats. *Courtesy of Lake County Historical Society.*

in a hand-written paper, states that Roby's Mill was on the Pere Marquette River near Ruby Creek. She says that Roby Creek became Ruby Creek by a simple spelling error.

Getting over Ruby Creek's rapids was a chore, and a bridge was built by a Mr. Wetherbe. Before the bridge, settlers had to either use a canoe or build a log raft to cross. Wetherbe also built the bridge over the Pere Marquette River at Tracy Rapids for the first lumber camp in the township (per the above-mentioned article). Where that was seems to be a mystery. On the 2008 map, there is a location in the southeast corner of Section 23 that is labeled Pere Marquette Woods and Rapids, but that is not a confirmation.

Although the lumbering industry was good for man, it devastated the forest and river ecosystem and thus fish and wildlife populations in our county. Without the trees, the former woodlands eroded into the rivers and lakes, dumping soil (in some places several inches to a foot) in the water and covering up much of the plant life and other food sources, killing the fish. This was bad enough that a sign at the Custer Bridge says that in the early 1900s, experts proclaimed that the Pere Marquette River was dead. Nature

did eventually right itself, although some species are gone forever. Thanks to watershed management, many species are returning.

A 2002 *Ludington Daily News* article by Brian Mulherin hints that Ludington salmon fishermen can thank George Townes, Glen Bowden and Walt Leversey for getting a salmon plant placed on the Pere Marquette River at Ruby Creek. It is on Washington Road west of Masten Road. Without this plant, the "Gold Coast" wouldn't shine.

*Mason County Pictorial History* shows Gillen School, which was built in 1899. Unfortunately, it doesn't show up on the 1904 plat map, which it should. However, we have a picture, and the files at the historical society research library contain a paper stating that Mr. and Mrs. Joseph Gillien came from Detroit and settled in the southeast corner of Section 14. He worked at Stearns Siding in Lake County. Perhaps this was the second McCumber School, which was a mile south of his home?

Logan Township was never a booming business area. There were mills but only two settlements, neither of which had a major industry. One business that has managed to remain afloat and shine through the hard times is Carr Telephone Service, today called Carr Communications, located on Masten Road in Carr Settlement. Not only did it survive, it evolved and added a cable and internet function as well. That is the secret to the survival of a settlement: evolve or become extinct.

Ruby Creek lost Roby's mill but still has a store and bar, not to mention the salmon plant on the Pere Marquette River.

# MEADE TOWNSHIP

A lthough a part of Freesoil Township until its creation in 1909–10, Meade Township's history goes back to the 1800s. It was called East Freesoil before it got the name Meade, which probably came from General George Meade, who is best known for his defeat of Robert E. Lee at Gettysburg. Having no modern villages or settlements, Meade was a major force in the lumber operations. With plenty of lakes and river frontage, it was made for it. Once the trees were cleared for lumber, seedlings were planted to be later harvested for pulp wood.

In the early 1900s, one of the major landholders was George Swigert, who bought up as much land as he could, as he did in Freesoil Township. Meade Cemetery was created on land purchased from Warren Cartier in 1911. The land along the Sable River belonging to Senator Charles Mears was later sold to the Pardee and Cook Company and the Morrisons for their lumber camps. Other camp owners were the Campbell brothers and the MacArthur brothers. So undeveloped was Meade that its first main east–west road was not built until 1935, says Mrs. William Tucker in a very old essay in the historical society's files.

In its early days, there were two settlements on record. Elmton was a settlement that grew around a depot along the Manistee & Grand Rapids Railroad (which ran across Sections 19, 29, 30, 32 and 33) on the Howell property in the southwest corner of Section 19. The Howell School, originally built in 1889, was just to the east of Elmton at the northeast corner of Freesoil and Larson Roads. A larger building was constructed in 1908. Although called the Manistee & Grand Rapids Railroad, the line never got

## Meade Township

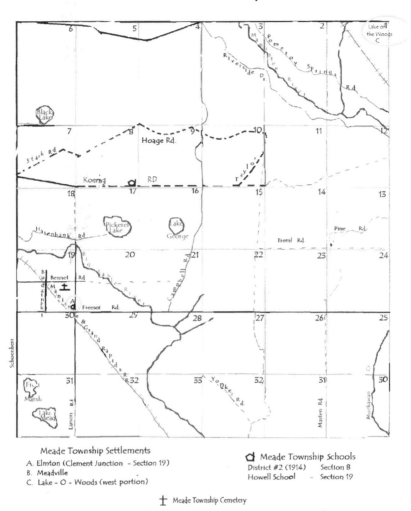

Meade Township Settlements
A. Elmton (Clement Junction – Section 19)
B. Meadville
C. Lake - O - Woods (west portion)

Meade Township Schools
District #2 (1914)      Section 8
Howell School    -    Section 19

✝ Meade Township Cemetery

to Grand Rapids. When the lumbering boom was over, the railroad was stopped. The farthest it got was to Tustin in Osceola County.

Clement Junction, according to a *Ludington Daily News* column and book written by David K. Peterson, was along the Manistee & Grand Rapids Railroad tracks near Elmton. It is possible that it was part of Elmton and there was only one settlement. No further information on it could be found, nor could a reason for the name be found, as there were no landowners with that name on earlier plat maps.

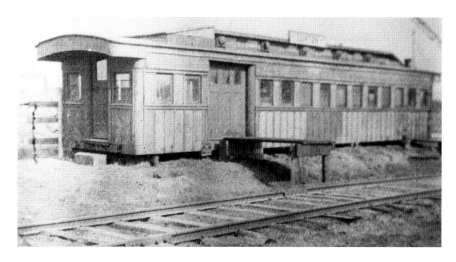

Manistee–Grand Rapids Railroad depot at Elmton, Meade Township. *Courtesy of Mason County Historical Society.*

Beside the Pere Marquette and the Manistee & Grand Rapids Railroads, Meade Township had another railroad whose location cannot be pinned down. The Manistee & Luther Railroad was owned by R.G. Peters (co-owner in the Butters and Peters Mills). Peters was a railroad man before he started in lumber. According to Doris Reid, Peter's narrow-gauge railroad came down into Meade Township lumber camps and hauled logs to his mill in Manistee. The railroad would put down tracks and work out of one camp and mill until the wood was exhausted, then tear up the tracks and lay down a line to another, thus serving many camps in northern Meade and recycling at the same time. A University of Michigan website on Michigan railroads tells that because of this practice, the Manistee & Luther Railroad had more injuries and deaths than the stationary railroads. The good news is that the abandoned railroad grades in the township became used as early roads, which were badly needed.

An article in *Mason Memories* says that Meadeville was on the east side of the county in Section 12, where the railroad added a switch; another author just says that Meadeville was a stop on the Manistee & Grand Rapids Railway in Meade Township. The historical society's files tell the truth in the form of a map that was part of an advertisement for Meadeville and an essay written by Helen Bartlett. Meadeville was a community created by George Swigert, who bought swampy land in Freesoil and Meade Townships and platted out a village and property lots throughout

## Meade Township

Meadville Property Lots

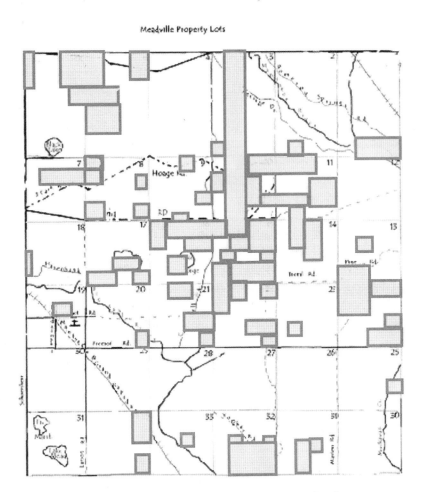

Meadevile Lots (boxes) were scattered about
Meade Twp., but the village was in Freesoil Twp.

both townships. He then sold to unsuspecting buyers at top dollar. The ad, which was run in a 1920 newspaper, shows all of Sections 1, 2, 12 and 13 in Freesoil Township, with many lots in mostly northern Meade Township. The actual village of Meadeville was in Freesoil Township Section 13 on the Michigan East and West Railroad (Manistee & Grand Rapids Railroad) line.

Mrs. Bartlett says the reason Meadeville didn't grow was "living was hard and people couldn't exist." She probably meant they could not thrive in swampy, unfarmable land with no settlements or transportation.

Dr. William Anderson, author and retired president of West Shore Community College, pointed out the trials of isolation in rural areas. In those early days, people couldn't just pick up and go to town, to the beach or the store. They had no cars. There may have been a horse in every barn—though probably not—but that horse was needed to eke out a living. It wasn't for transportation but survival. If the family was fortunate enough to have a horse, they certainly couldn't all ride it at the same time, and there were no roads to pull a wagon on.

Supposedly, Ed McCumber of Logan Township and his neighbor William Perring built a road so they could get through with their oxen. Until then, all they had were footpaths in the woods. That is what these people dealt with. If your farm wasn't self-sustaining, it'd be hard to remain.

Meade is blessed with two rivers, the Little Manistee River in the northeast corner and the Big Sable River, and their tributaries. In the southeast corner of the township, Muckawan Creek is located in Sections 25 and 36. Several small lakes dot the township, with Black Lake in the north in Section 6, named for landowner Ed Black. In Section 16 is Lake George, a mud lake on the 1904 plat map. To the east in section 17 is Lake Feil (unnamed in 1904), now named Pickerel Lake. Frog Marsh and Lake Meade are located in the southwest in Section 31 on current plat maps but are not on earlier maps.

The first school in the township was Bittel School, but its location is unknown. There was also a Bittel School in Grant on the Tainer/Bittel farm. District Two School was built in 1914 on Koenig Road and Tuttle Road at the southeast corner of Section 8.

One final place research speaks of is Bear Swamp, which could actually be anywhere in Mason County, but Mrs. William Tucker says it was the location of the Bennet Lumber Camp in Meade. There is a photograph of Bennet Lumber Camp in *Mason County Pictorial History*, so we know it existed. In 1904, John Bennet owned property in Section 16 in Meade Township. Bennet & Son owned property in Section 21 in 1915.

Meade, whose forests once echoed with the sound of the axe and horses, has gained no other industry to support its people. They must go elsewhere for work. The government bought up much of the land, and township supervisor Lois Krepps says that today, the township is 55 percent Huron-Manistee National Forest.

# PERE MARQUETTE TOWNSHIP

Pere Marquette was one of the original three townships of Mason County, along with Freesoil and Lincoln, in 1855. The history of Pere Marquette is well known and is tied to that of the city of Ludington, which occupies much of its area. The township extends from the Lincoln River in the north to Summit Township in the south. Lake Michigan borders its west and Amber Township its east.

Pere Marquette Township was named for Pere (Father) Jacques Marquette, a French Jesuit missionary who died here in 1675. The earliest resident, Joseph Wheeler, came in 1840. Pioneer notes and letters reveal that Ludington Avenue, the main route through the city, didn't really become a thoroughfare until late in its history. In 1860, Henry Guernsey was on his way to his homestead when he found today's Ludington Avenue under water and surrounded by cattails. Another settler states that in 1898, Ludington Avenue was a wood-cobbled street as far east as James Street but dirt the rest of the way to Washington Avenue.

In an article on her memories, Emily Dowland states that Pere Marquette Village lies to the south of Ludington Avenue. A sawmill, store and boardinghouse were on South Main Street (Gaylord Street). There were two houses, a very large one and a small one, on Sawdust Avenue (which ran around the mill). East of the mill was a small building that became the school. The store became a broom factory. This all became part of Ludington (see image on page 91).

## Pere Marquette Township

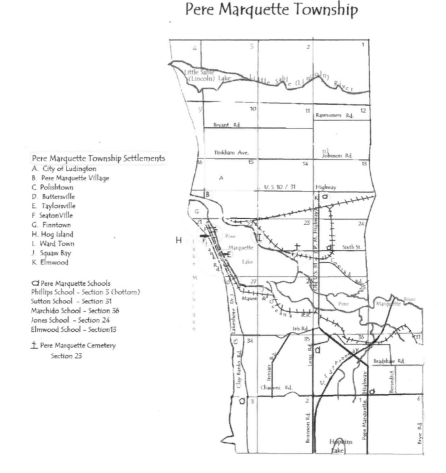

**Pere Marquette Township Settlements**
A. City of Ludington
B. Pere Marquette Village
C. Polishtown
D. Buttersville
E. Taylorsville
F. Seatonville
G. Finntown
H. Hog Island
I. Ward Town
J. Squaw Bay
K. Elmwood

◻ Pere Marquette Schools
Phillips School - Section 3 (bottom)
Sutton School - Section 31
Marchido School - Section 36
Jones School - Section 24
Elmwood School - Section13

✝ Pere Marquette Cemetery
Section 23

Another article written by Edwin Dowland, who at one time worked at the "Old Store" in Pere Marquette Village, states that there was a mill at the south end of William Road (Beane and Baird Mill) and that Charles (Rath) Avenue was the eastern boundary in the 1870s. At that time there was just one horse and buggy in the village except when visitors came. An Indian encampment on the riverbank where the Fourth Ward bridge is today held three hundred or more people. Dowland said he had to learn to speak their language to wait upon them.

He also said that the original Pere Marquette Cemetery was two miles south of Ludington on the road to Pentwater. Perhaps he was talking about Phillips Cemetery, going south across the Buttersville peninsula, or

today's Pere Marquette Cemetery. The latter was originally called the Polish Cemetery, as it was a cemetery for Polish Town, or the Catholic Cemetery, as St. Stanislaus Catholic Church, which served Ludington's Polish population, handed the cemetery over to Pere Marquette Township. The cemetery was just north of Polish Town, up the hill behind it on the road to Pentwater.

Paul S. Peterson, author and former editor of the *Ludington Daily News*, mentions in his book on Ludington that a creek began by today's county jail on Rowe Street and ran west to Rath Avenue, where a pond was located, and then went southwest, crossing Ludington Avenue and south into Pere Marquette Lake.

In the Winter 1987 *Mason Memories* newsletter, an article speaks of a place known as Whiskey Hill that was located on Dowland Street where the old Plumb's store would later sit. Whiskey Hill was a seventy-five-foot-high sand dune on which sailors and dock workers would sit (with a bottle of whiskey) and watch for the ships. At that time, jobs were hard to get, and the first ones to get there got the job. Rose Hawley didn't say how many slept through the ships coming and going.

The city of Ludington is within Pere Marquette Township and was originally called Pere Marquette Village. The story goes that someone, whether the village officials or the U.S. postmaster general, thought that the name was too similar to Marquette, Michigan, and wanted the name changed. James Ludington, the new owner of Ludington's first mill (or Luther Foster, his mill manager), took advantage of this and offered a large donation (some say $5,000 for a new city hall and library) to have the village named for him. Needing a new city hall, the commissioners accepted the offer. Rose Hawley states in her article on the event that the city never received the money. James Ludington came into possession of the mill by loaning money to George Ford, owner of the former Beane and Baird Mill. When Ford's finances failed and he couldn't make his payments, Ludington took possession of the mill and the rest of Ford's property in Ludington. This land became the first addition to Ludington.

It is interesting to note that James Ludington, who was born in Putnam County, New York, in 1827, never lived in Ludington, nor did he stay more than a week per visit. There is another city of Ludington in Wisconsin, which he didn't live in either. He lived his life in hotels in Milwaukee. He is responsible for building roads and bridges in the community, although mainly for his business purposes. Most of his Ludington business matters were handled by Luther Foster and Colonel John Loomis.

The railroad has played a major role in Mason County and was one of the main employers. Receiving a federal land grant, the Flint & Pere

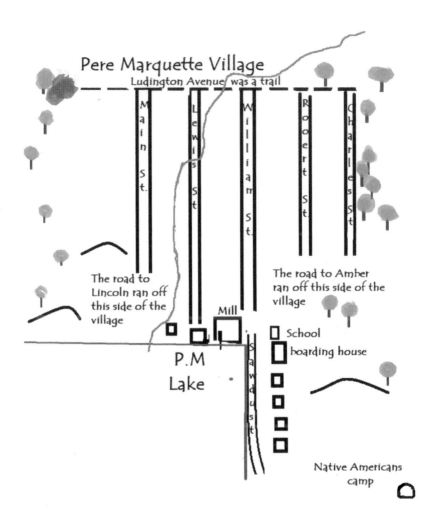

Pere Marquette Village
Ludington Avenue was a trail

Main St.
Lewis St
William St.
Roort St
Charles St

The road to Lincoln ran off this side of the village

The road to Amber ran off this side of the village

Mill

P.M Lake

Sawdust

School

boarding house

Native Americans camp

Marquette Railroad was established in January 1857 to create an east–west railroad across Michigan from Flint to Lake Michigan. Named for the French priest Father (Pere) Marquette, the first line ran from East Saginaw to Mount Morris (near Flint). In January 1862, the twenty-six-mile line was completed, and in 1866 the company began its westward expansion. The company's first westward station was in Midland. From then on, the railroad made its way toward Lake Michigan.

In 1868, Detroit millionaire Captain Eber Brock Ward took over management of the Flint & Pere Marquette Railroad and attempted to negotiate for property in Ludington for a railyard and mill with James

Ludington. Fearing Ward would take control of the city, Ludington refused to sell and asked Ward to sell him his timber property. At an impasse, Ward had a secret weapon. He knew that Ludington's lumbermen were cutting trees on Ward's property, so he waited until Ludington came to Detroit and had him arrested. Being a powerful Detroit businessman, Ward convinced the judge to level a hefty fine on Ludington that would basically wipe him out financially. At this time, Ludington had a stroke and was paralyzed and forced to retire. His company, Pere Marquette Lumber Company, stepped in and negotiated the sale of the railyard with docks and property for Ward's mills.

According to the *Milwaukee Journal*, Ludington became totally bedridden after his stroke, so much so that when the hotel he lived in caught fire, he was unable to help himself. Fortunately, others came to carry him from the burning building. He died as a bachelor about twenty years later in 1891 in Milwaukee, where he is buried.

To the south of Pere Marquette Village is Pere Marquette Lake. Fed by the waters of the Pere Marquette River and its tributaries, it empties into Lake Michigan, although in a different location than it did when the first settlers came.

In his book *Historic Not-a-pe-ka-gon*, Russell Anderson has a hand-drawn map that shows that in the 1600s, the opening to Pere Marquette Lake was just to the south of where the Pere Marquette Memorial is today. By the 1840s, the channel had drifted farther south to the Buttersville end. It was rather shallow—some described it as a brook—and only small vessels or scows could enter the harbor.

Charles Mears, who rented the mill on Pere Marquette Lake from James Ludington, needed a better, deeper harbor to transport his lumber to Chicago (as did Ludington to make his city grow), so Mears (and possibly Ludington, hints Paul S. Peterson) decided to move the entrance to the other end of the peninsula. Clay Banks residents and Burr Caswell objected and wrote Washington; however, Mears and Ludington had already been to Washington and used their influence to gain approval. So Mears—who had a background with canals and locks—came with thirty-six men, opened up the north end of "the island" and filled in the south channel opening. At one point, he had to hire guards to keep Clay Banks residents from reopening their old channel.

It might seem to many that it would be much easier to dig the south opening deeper and wider and make the harbor there. However, that southern location was in frequent need of dredging, as the winds and the waves kept filling it in.

Once the harbor was opened, ships were able to come and go, and the town grew tremendously. More lumber barons came in. The Flint & Pere Marquette Railroad finally connected its terminus at Ludington on Lake Michigan to the eastern and southern side of the state in 1874. The railroad also helped move logs to the mills from the lumber camps away from rivers.

To help carry the lumber and other products to markets in Chicago and Wisconsin, it added a sidewheel boat. After leasing boats from a Milwaukee shipyard, the company decided to build its own and in 1876 launched the wooden steamboats *F&PM 1* and *2* to carry merchandise and people across the lake. Called the "Black Boats" because of their color, boats *1* through *5* were later known as PM steamers.

The steel-hulled, steam-powered car ferries came around 1896 with the *Pere Marquette*, which was renamed *Pere Marquette 15* in 1901, although the name didn't reach the surface of the boat until 1929. Car ferries were a revolution. Before, merchandise was brought to the docks and then reloaded on the boat and had to be unloaded on the other side of the lake and reloaded on other forms of transportation to reach its destination. With the car ferries, the merchandise was already on a railcar, which was loaded on the boat, taken across the lake, removed from the boat and attached to a train. This eliminated a labor-intensive step and sped things along.

The *15* was such a hit that the company ordered others, and the *Pere Marquette 17* through *20* arrived between 1901 and 1903. With such a fleet, new ships would not be ordered until 1911, after the *18* sank in Lake Michigan with major loss of life. The *Pere Marquette 21* and *22* came about 1924. In 1929, the *City of Saginaw 31* followed, along with the *City of Flint 32*. With twin propellers, these two took on Lake Michigan icepacks. Dan Bissell, son of *Spartan* captain John Bissell, says they would back into the ice, and the propellers would chew it up. The *City of Midland 41*, *Spartan* and *Badger* took the ice on with their icebreaking hulls. Unfortunately, that doesn't help if

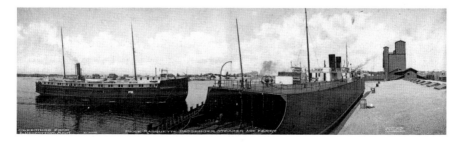

*Pere Marquette 15* coming to dock, with another Pere Marquette car ferry waiting to access grain elevator. *Library of Congress.*

Pere Marquette car ferries *15, 17, 18* and *19* stuck in ice in Ludington harbor. *Photograph by Esten Bahle, captain of* City of Flint, *courtesy of great-nephew Karl Bahle.*

*City of Midland 41* with broken propeller and *Judy Ann* stuck in ice at harbor entrance. Mr. Walters returns to his boat after walking to Bonser's store for provisions. *Photograph by Todd Reed, courtesy of Todd and Brad Reed Photography.*

the thick ice breaks the blades off the propellers. Mike Braybrook says that was the case with the starboard propeller on the *City of Midland 41*—one propeller isn't enough to break ice.

The wonder twins, *31* and *32*, were followed by the *City of Midland 41* in 1940. At 406 feet long, it cost over $1.75 million to build. This boat hauled freight, but an emphasis was put on passenger comfort. It sailed its final trip as a car ferry in November 1988. The *Spartan 42* and the *Badger 43* would follow in 1952.

When the Chesapeake and Ohio (C&O) Railroad bought the Pere Marquette Railroad in 1947, some of the boats were still called *Pere Marquette* followed by a number—like the *Pere Marquette 21* and *22*, which were operated in the 1960s and 1970s—and others were named for Michigan cities, such as *City of Midland 41*, *City of Saginaw 31* and *City of Flint 32*. The *Spartan* and *Badger* were named for the mascots of Michigan State University and the University of Wisconsin to avoid insulting any of the many cities that applied to have the ships named for them. By the time my dad brought us to Ludington, the *City of Flint 32* and *City of Saginaw 31* were retired in the 1960s. Although the *Spartan* and *Badger* were newer and bigger (by four feet), my dad liked the *Midland* because, as he put it, "she was a luxury liner of Lake Michigan." From what I've seen of the interior of the *City of Flint 32*, it was pretty luxurious as well.

Of course, all good things come to an end. In the 1970s, looking to cut costs, C&O began trying to discontinue service in the Ludington area, including the car ferries. In 1983, it won the court battle to idle the *City of Midland*, *Spartan* and *Badger*. Several old car ferry employees say that the boats were deliberately neglected by the company and allowed to go to ruin. Could C&O have been trying to show a loss for the courts? Some of the remaining *Pere Marquettes* were sold for scrap, one was cut down into a barge, and a couple were given a new life as ferries in the Straits of Mackinaw.

In 1983, the remaining boats were bought by Glen Bowden and Lake Michigan Transportation Company. In 1997, the *City of Midland 41* left Ludington harbor for the last time and was towed to Muskegon, where it was cut down and altered to become the barge *Pere Marquette 41*. Still owned by the same company as the *Spartan* and *Badger*, its home port is Ludington, but it has a new job.

Just as this book is about lost and abandoned towns, we have a case of lost and abandoned boats. If you visit the car ferry docks, you will see the empty hull of the *Spartan*. The insides and working parts were taken and reused to keep the *Badger* going. It is a shame that such a great boat is left to rust. It's

Barge *Pere Marquette 41*, formerly *City of Midland 41*, still works out of Ludington, run by the Pere Marquette Transportation Company. *Courtesy of Dan Bissell.*

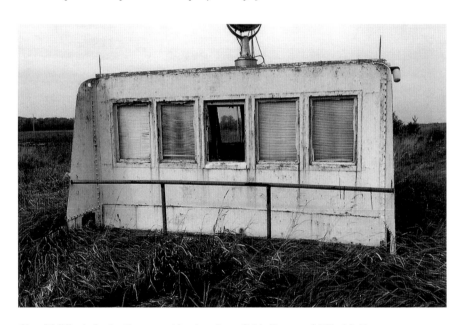

*City of Midland* aft wheelhouse waiting in a farm field. *Courtesy of Mike Modderman.*

too bad we couldn't turn it into a floating museum or restaurant to go with our maritime museum. The *Badger* continues its daily run from May through October and is advertising lake cruises.

In the retrofit of the *City of Midland*, the aft wheelhouse was cut out, and today it sits in an Ottawa County farm field, saved by a car ferry lover who cannot use it. He is working to help restore the *City of Milwaukee* as a floating museum in Manistee. The *Milwaukee* was built by the same company as the *Pere Marquette 21* and *22*. The *City of Milwaukee* performs as the "Ghost Ship" at Halloween and as a bed-and-breakfast in the summer. Unfortunately, work is hampered by a lack of volunteers to help restore the boat. Volunteer Mike Modderman tells me that there are only five or six regular volunteers trying to do the work. If you are an old naval and marine worker or buff who might be able to help, please do!

You may be wondering with all these car ferries named after cities, where is the *City of Ludington*? The first boat used by the Pere Marquette Railroad to aid in transporting merchandise was the sidewheel boat *John Sherman*. The ferry was a success, and the railroad hired the Goodrich Transportation Company to transport merchandise for it. Seeing the success that the Pere Marquette Railroad was having transporting goods, Goodrich built the *City of Ludington*. The port of Ludington was not its home. It was later sold and renamed the *Georgia*. It existed long before the *City of Flint*, *Saginaw* and *Midland*.

So back to the rest of Pere Marquette Township. Polish Town was located on the north banks of Pere Marquette Lake south of Pere Marquette Cemetery on what is now Dow Chemical property. It was a row of houses along Old Smokey Road, a cinder road that was a shortcut from Ludington to Pentwater. The history of the Polish people in the Fourth Ward makes me think these people gravitated up the hill as industry demanded more waterfront.

Another settlement that grew around the mills was Ward Town, between Captain Eber Ward's North and South Mills on the east side of Pere Marquette Lake. The South Mill, considered the finest mill in the country, was run by E.B. Ward's son Milton. After Ward's death in 1875, the mills and other property was inherited by Ward's wife, Catherine, and her two brothers, Thomas and John. Thomas managed the businesses. Around 1892–93, the South Mill closed due to lack of logs. It caught fire and burned down in 1895, taking several other mills and stockpiles with it. Lyon later sold the North Mill to brother-in-law Justus Stearns, who added salt wells. Ward Town later became part of the Fourth Ward south of the river.

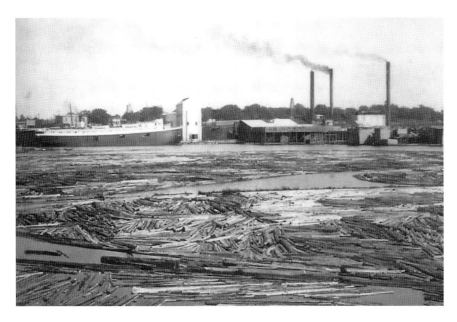

Stearns Salt and Lumber Company's (formerly Ward's) North Mill. You can see derricks for the salt wells on the left and near the smoke stacks. *Courtesy of Ron Lessard.*

An article in the September 9, 1970 *Ludington Daily News* says that in the early 1900s, Pere Marquette Township had a community pest house where those who had contagious diseases were quarantined. The article states that the pest house was located where the old Giantway Plaza was along U.S. 10/Ludington Avenue, today the strip mall at the corner of U.S. 10 and Nelson Road behind the parking lot where the Amish bakery, Little Caesars and Spanky's Pizza are.

Creamery Corners, at the Sixth Street–Old 31 (Pere Marquette Highway) intersection, was the location of a dairy. Down the hill and past the twin bridges west of Old 31 was River Road, which today is Iris Road. On Lake Michigan's shore and Pere Marquette Lake's southern shore was the beginning of the Clay Banks and the Buttersville peninsula, with Finn Town, Seatonville, Taylorsville and Buttersville. Middle Road ran through Pere Marquette and Summit Townships. Clay Banks Road ran through Pere Marquette Township and Summit to Bass Lake and is now South Lakeshore Drive.

Buttersville was the second-largest settlement in the township. Located in northern Section 27, it was founded by Horace Butters, who bought a mill in 1882. This mill had four or five owners in the previous ten years. In 1874,

he and partner Richard G. Peters of Manistee created the Mason & Oceana Railroad, which traveled out into the lumber camps in Eden Township and then down to Oceana County. In 1882, the mill grew into the Butters and Peters shingle and salt block. The community grew around the mill, adding a post office in 1887. It had a general store, boardinghouse, recreation hall, church, school and about fifty houses. It was quite self-sufficient. It is interesting to think that Buttersville had 1,000 residents, and another 300 rode the ferries from Ludington to the North and South Mill docks every day to work. The mill burned in 1892 and was rebuilt. The post office closed in 1907. In 1909, a fire started in the Hog House, a building where wood was ground up for fuel, and the mill burned and was not rebuilt. The railroad stopped running by the year's end, and most of the houses were removed to Ludington. Buttersville became a ghost town. Pig Tail Alley, one of the community's roads, was empty, and 1,300 workers were out of a job and their family out of an income and home.

Hog Island is the early name given for the Buttersville peninsula. It is unknown why, but it's possible that the reference to hog buildings, hog chimneys in the mills and Pig Tail Alley in the settlements might have something to do with it. On the other hand, Rose Hawley brings up in *Mason Memories* an old story that the first permanent settler, Burr Casswell, had a son, George, who when grown to manhood settled on the peninsula at the base of a hill and had a large pen of pigs. (Remember that the original mouth of Pere Marquette River and Lake was at the Buttersville end of the peninsula before Charles Mears moved it.) One night, a huge storm came in and washed thirty feet of the shoreline away, taking the pen and pigs with it, so the area was called Hog Island. In this article, she also mentions Muskrat Point, which she says was located at the North Transportation Docks.

Taylorsville was just south of the Pere Marquette Memorial. It extended from Buttersville to Seatonville. The mill was built in 1872. Oliver N. Taylor bought a share in 1880 and soon bought his partner out. In 1883, he and his brother started the Taylor Brothers firm. They built a boardinghouse for workers, and by 1888, the community had three hundred residents. The mill closed in 1895 and was removed in 1898, and the property was bought by Stearns Salt and Lumber Company. This community was abandoned by 1917.

Jacques Marquette was born in France in 1637. At the age of seventeen, he joined the Jesuit Order of the Catholic Church. In 1666, he was sent to be a missionary in America. Stationed at Sault Ste. Marie and then St. Ignace, he led many missions to preach to the native peoples around Lake Michigan,

Pere Marquette Memorial, seen from Pere Marquette Lake, Old Taylorville site, 2018. *Author photograph.*

down to the Mississippi River and then back to St. Ignace, Michigan. On his final return trip, exhausted and dying, he directed his Native American guides to put in at the small inlet on Pere Marquette Lake and pointed out where they were to carry him. There he died on the hill of his choosing in 1675 at the age of thirty-eight, after instructing his companions to bury him there and place the cross he wore on his chest on his grave. This place became a sacred spot to French voyageurs and Native Americans alike, as well as the Jesuits in the region. His bones were removed a couple of years later and taken to St. Ignace. The inlet and river were named the River of the Black Robe by the local Native Americans. When people came two years later to dig up his bones and return with them to St. Ignace, they didn't get all of his remains—they took the bones, but the rest of his body had already seeped into the soil of that place.

Today, the cross marks his original burial place. There have been attempts to get the cross removed, but it's insulting that people would try to force Pere Marquette Township to remove the cross from a priest's grave. There are crosses in nearly every cemetery in this county (and state, one would imagine). Government units own those cemeteries, and there are crosses on many of the graves that don't seem to be challenged. Those graves belong to the interred and their family. Why should Marquette's grave on public property be any different than any other graveyard? It was the deceased's wish to have a cross on his grave. That wish has been honored since his death.

Just north of Taylorsville on the peninsula was Seatonville, another lumber community built around the Elwin Seaton and Stephen Butters shingle mill, built in 1871. (This Stephen Butters was not Horace Butters's son Stephen, who was seven at the time.) The mill burned in 1877, was rebuilt and burned again in 1888. Seaton lived beside the mill, which burned again in 1889. He moved his home to Ludington in 1892, and the community was abandoned. The burning of the mills put over 1,600 people out of work, and they and their families were forced to relocate.

Finn Town (also called Finlander Town, Finn Island or just the Island) is at the north end of the Buttersville peninsula. It was considered part of Pere Marquette Village and Ludington before and after the channel was moved. It was a commercial fishing village of small houses and shanties nestled on the protected shore of Pere Marquette Lake inside the harbor, and its residents were of Finnish and some Swedish heritage. The children went to school in Buttersville or took the foot ferry (a scow) that ran from the island across the channel to attend school in First Ward. Eventually, Stearns

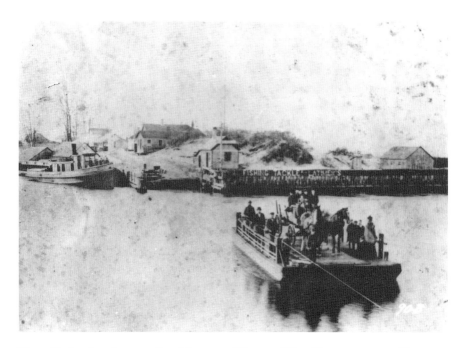

The cable foot ferry between Pere Marquette Village and Finn Town was operated by Charles and William Gerard. Finn Town is in the background. *Courtesy of Mason County Historical Society.*

Salt and Lumber Company bought the land and forced the fishermen and their families to relocate, although a dozen of the commercial fishing boats went out from the area for many years after. Crosswinds Condominiums now occupy the location. The original life-saving station was at Finn Town. The U.S. Coast Guard station lies across the harbor today.

Squaw Bay, named for it being a romantic rendezvous spot for the Native Americans, was on the southern end of Pere Marquette Lake. The lumbermen called it the Sorting Gap, while the Mason and Oceana County railroad men called it the railroad's entrance to Buttersville. The railroad line followed a very sharp curve along the shore that was difficult for the train to negotiate. It is now Sutton's Landing, a small park and river access point owned by the township. (Please be aware that in some Native American languages calling a woman a squaw is an insult.)

Built in 1882, the Plank Road was made of wooden planks from the timbers that Mears used and removed while moving the channel opening from just north of Buttersville Park to the north end of the peninsula in 1860.

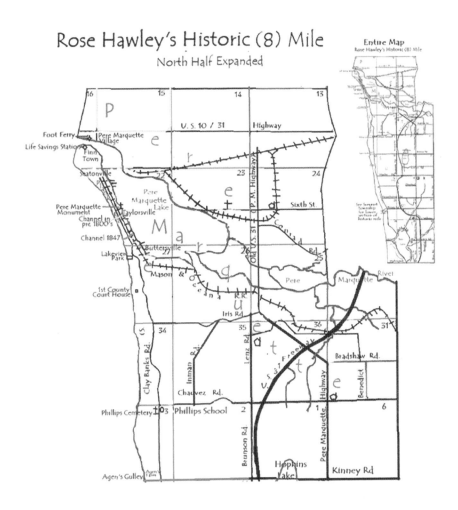

South of Buttersville in Section 1 lies the northern half of Hopkins Lake. East of U.S. 31 and west of Old 31 at Kinney Road, Swanson Creek begins near Pere Marquette Highway and Meyers Road and runs across Section 36 to Hopkins Lake. Mosquito Creek begins in Amber Township north of Conrad Road near Meyers Road and flows to the Pere Marquette River.

Other old communities had schools not mentioned above. Phillips School was in a log cabin on the Barber farm in 1856. The second was built in 1860 on South Lakeshore Drive, and the third was built in 1868 in Section 2 on the southeast corner of South Lakeshore Drive and Chauvez Road on Almonza Phillip's property, across from Phillips Cemetery. Marchido School was located in Section 36 on the southeast corner of Bronson and Hesslund

Road on the E. Marchido property. The building was moved to White Pine Village, which sits on the old Burr Caswell property. Burr Caswell was the first permanent white settler in the county. The Caswell home, which served as a trading post, post office, courthouse and jail, sits in its original location. Sutton's School was on the north side of Chauvez Road a mile and a half east of Pere Marquette Highway. It was moved to the northeast corner of Pere Marquette Highway and Chauvez Road. Jones School was in Section 24 on the north side of Sixth Street on the west side of the railroad tracks. The 1904 plat map shows a school in Section 13 on the south side of U.S. 10 on the Clauson property (about where the Big Boy is today). This is the location of a settlement known as Elmwood on the map.

Truman French, in his weekly column in the *Ludington Daily News* in 1916, mentions a settlement called Goodrich after a property owner in Pere Marquette Township, although the name does not appear as a property owner on the 1916 plat map. Goodrich was south of Crystal Valley in Oceana County. If you look at the city addition map, you will see a Pere Marquette Village in a different location. In 1871, S.F. White platted an addition to Ludington that he called Pere Marquette Village. Although this was a good intention, it is not the original Pere Marquette Village.

This Mason & Oceana engine and coal car replica is on display at Historic White Pine Village in 2018. *Courtesy of Stephanie Malburg.*

Pere Marquette Township today has none of the mills that filled the air with smoke and kept the locals employed. The sounds of the mills and mill workers are gone around Pere Marquette Lake. It does have plenty of businesses in spite of losing land every time an addition to Ludington came up. Today it is called Pere Marquette Charter Township, which means that it has more rights and ruling abilities than an ordinary township—it is more than a village but less powerful than a city.

The settlements on the peninsula are gone, but in their places, homes have cropped up. Finn Town is now a condominium complex. The coast guard is across the harbor. Up the hill on South Lakeshore Drive, a life-size museum has grown around Burr Casswell's home, trading post and courthouse along with historic buildings from around the county. Historic White Pine Village is a star among the tourist sites in Mason County as well as a must-see for locals. Most of the buildings in the village were constructed by or contain furniture and equipment used by early settlers in our county.

The village contains the original courthouse, an original school, log cabins from the Siddons Settlement and Fairview, William Quevillon's home, and more. Please visit often, because it seems to change every time one turns around. One weekend in the summer, it holds a free admission day for county residents, and it also hosts holiday mini-festivals.

The village's latest wonder is an actual steam locomotive. The Mason & Oceana Railroad is alive again. Farther down Lakeshore Drive is the Consumer's Energy–DTE Hydroelectric Pumped Storage Plant, one of the other wonders of our county.

# RIVERTON TOWNSHIP

Originally part of Pere Marquette Township, Riverton Township was created in 1868 after a failed attempt the previous fall. At that time, it included Eden and Logan Townships and was bordered by Pere Marquette Township on the west, Amber Township on the north, Lake County on the east and Oceana County on the south. Today, it is bordered by Summit and Pere Marquette Townships to the west, Amber Township to the north, Eden Township to the east and Oceana County to the south. With the Pere Marquette River as its northern border and the Pentwater River near its southern border, Riverton's name came from being on the river.

Settlers came as early as 1852 and made Riverton one of the finest fruit-growing areas in the county. An article in the county historical publication says that there are no ghost towns in Riverton. However, there are ghost settlements. As mills and rail lines came and went, with them went small settlements.

In the early days, there were three Riverton settlements. However, they all called themselves Riverton and had their own post offices, and so they had to add locations: East Riverton, West Riverton and Center Riverton. An article or two point out that the original settlement was just Riverton and was situated near the intersection of Stiles Road and Chauvez Road. Although that is the location of the Riverton Store today, it said that there was a post office on the north side of the intersection. Ernie's Rollway was north of the intersection on the banks of the Pere Marquette River (Section 33 or 34).

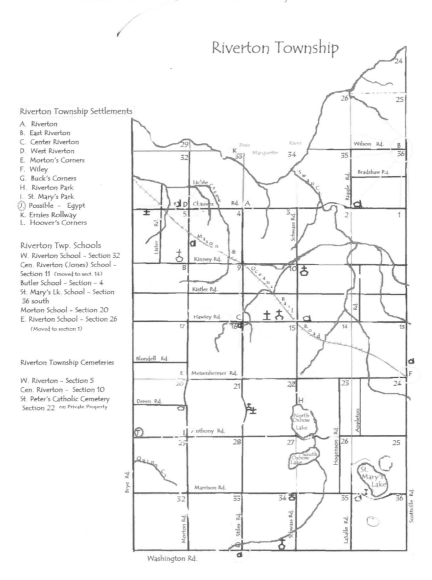

Riverton Township

Riverton Township Settlements

A. Riverton
B. East Riverton
C. Center Riverton
D. West Riverton
E. Morton's Corners
F. Wiley
G. Buck's Corners
H. Riverton Park
I. St. Mary's Park
J. Possible – Egypt
K. Ernies Rollway
L. Hoover's Corners

Riverton Twp. Schools

W. Riverton School – Section 32
Cen. Riverton (Jones) School –
Section 11 (moved to sect. 14)
Butler School – Section – 4
St. Mary's Lk. School – Section
36 south
Morton School – Section 20
E. Riverton School – Section 26
(Moved to section 1)

Riverton Township Cemeteries

W. Riverton – Section 5
Cen. Riverton – Section 10
St. Peter's Catholic Cemetery
Section 22 on Private Property

East Riverton was first settled by the Hull brothers, Myron and Charles, who came from Scottville. It centered on the southeast corner of Section 26 and the northeast corner of Section 36 at the South Scottville–Wilson Road intersection. Evidently, it extended to Stiles Road. It had a post office, and the school, built in 1870, was located on the north side of Chauvez Road at Riggle Road. In 1880, it was moved across Chauvez Road.

Center Riverton was located around the intersection of Hawley and Stiles Roads in the southwest corner of Section 10 and the southeast corner of

Section 9. The hall was located on the northwest corner. Today, it is farther east, between the cemetery and the fire barn on the north side of Hawley Road. Center Riverton School, built in 1883, was on the northeast corner of Hawley and Schwass Roads and was also called Jones School.

West Riverton was around the intersection of Chauvez and Morton Roads. The cemetery is west of the intersection on the south side of Chauvez Road. West Riverton School, built in 1867, was on the north side of Chauvez Road between Lister and Morton Roads. It was moved in 1887 to the east side of Morton Road between Chauvez and Kinney Roads and renamed Butler School.

Morton's Corners was at the Morton–Meisenheimer Road intersection, near the David and Alex Morton farms. Morton School was built in 1883 on the southwest corner of Morton and Deren Roads. To the south is Hoover's Corners at the Morton–Anthony Road intersection. It was probably named for J. Hoover's family, whose farm was on the southwest corner.

Buck's Corners was on the Mason–Oceana County line at Stiles and Washington Roads. A school and store were on the Oceana side of the settlement. The community was named for Sylvanus Buck, who brought his family to the area from Chemung, New York, in the early 1860s. Pleasant View Store was a half-mile east of Buck's Corners on the north side of the road.

St. Peter's Catholic Cemetery is in Section 22 on the east side of Stiles Road. The cemetery is in the woods beneath the Consumers Energy electric lines. St. Peter's Catholic Church once stood beside it before burning down.

Squireville was at the corner of Marrison and Schwass Roads. It was probably named for the Percy Squires family, which settled there. The settlement had a post office, blacksmith shop and general store. The post office was on the northeast corner, inside the store.

East of Squireville, St. Mary's Park was located on the south side of St. Mary's Lake north of Marrison Road before LaSalle Road. At one time, it had a small gathering building and picnic areas, as well as outhouses. It remains one of the local swimming holes. Built in 1895, St. Mary's School was on the southeast corner of LaSalle and Marrison Roads. It's unclear if there was a store in the area, but there was a blacksmith shop. Most of the people of these rural areas got their mail via delivery to the school, where it was taken home by the children.

Riverton Park was on the north side of North Oxbow Lake in Sections 22 and 23 off Anthony Road. South Oxbow Lake is on private property in Section 26 and 27. Several articles and books mention Miranda's Pond. One

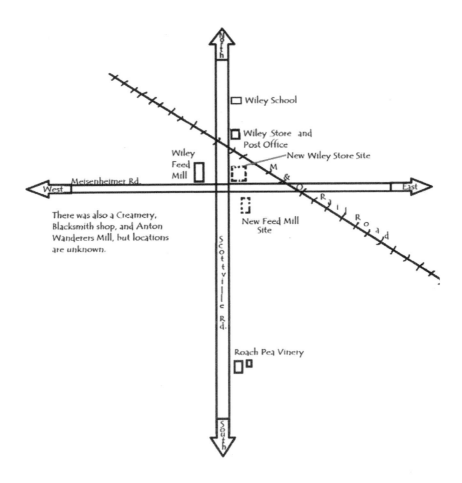

states it was across the road from John Saltzgaber's blacksmith shop, which was located in Section 32 in west Riverton Township per a September 1, 1898 *Ludington Appeal* community news article.

One place of the past that has eluded people is Egypt, which may have been in Riverton Township. Records show that a post office named Egypt was assigned to Frederick King in 1882. There are no census or township plat records of that time to give us a clue, but the post office record says that Fred E. King was appointed in 1883. Whether this is the same person or his son is unknown; it doesn't seem likely the same person would be reinstated six months later, though it has been done. The post office closed in 1884, and its mail was forwarded to Ludington, so it had to be on the west side of the township. The only other evidence available is an 1883 city directory, which places Fred King, a farmer, in the southwest corner

of Riverton Section 20. This might be it (after all, Egypt was to the west of Eden).

Wiley Settlement was on South Scottville Road at the intersection with Meisenheimer Road. It was named for Lemuel Wiley, who lived west of the corners. The west half of the Wiley Settlement was in Riverton, where Wiley settled in the 1870s to farm, and the east half was in Eden. The Mason & Oceana Railroad crossed just north of the corners and had a stop there. The store, creamery and pea vinery were in Eden, as was the school. D. Peterson states that there was another pea vinery before Roach built its on the edge of the Sherburn property. The feed mill was on the northwest corner, in Riverton; it was later moved to the southeast corner. Lemuel Wiley soon left the area to go to Oregon.

A letter written to Rose Hawley by John Appleton spoke of the boon the Mason & Oceana Railroad meant for the rural residents, as they were given jobs in building it and keeping it running smoothly. An article written by Effie Harley Bigsby (daughter of Jacob Harley) stated that the railroad had a station in Riverton on the Isaac Harley property beside the first Riverton Store and Post Office, owned by Isaac's son Jacob Harley. There was also a mill at the location. The author stated that the train didn't stop unless it had need or was flagged down. As in Wiley, it went by in the morning and returned in the afternoon. After acquiring the Wiley Store, Mrs. Harley ran the Riverton Store and Jacob Harley the Wiley Store, which he also owned.

Swan Creek crosses Scottville Road about one and a half miles north of Wiley and south of Kinney Road and flows north to the Pere Marquette River. Lickte Creek begins near Gerber Road and flows north to the Pere Marquette River. Quinn Creek begins near Morton Road between Anthony and Marrison Roads and runs into Summit Township.

Riverton Township doesn't seem to have been as heavily into logging as the others except along the Pere Marquette River. There were mills here and there, but no communities seemed to grow about them. I do remember seeing a photograph of a small portable mill on a scow. The railroad was the big employer, as locals helped build and service those tracks. When the lumber industry died out, the train was no longer needed to haul the lumber from the outlying camps and mills. The passenger end was not used enough to keep the train going, so the tracks and rails were pulled up (at least they recycled). Gone are the few settlements and the stores and shops that went with them.

Riverton today is a farming community, as it was years ago. However, the farming community has given rise to large packing plants, such as the Indian

Mason & Oceana Railroad engine replica on display at Historic White Pine Village. *Courtesy of Stephanie Malburg.*

Summer fruit processing plant on Chauvez Road and the House of Flavors Storage and Indian Summer plant on Pere Marquette Highway. Lake Winds Energy Park covers most of Riverton Township with gigantic wind turbines for electricity. There were some that objected, but for this retired science teacher, it is a site to behold.

An article in *Mason Memories* mentions that Peachville Settlement was in Riverton and was a stop on the Mason & Oceana Railroad. A small book by Robert Garasha, *Mason & Oceana Railroad*, states that the railroad did go across Riverton Township and that it did indeed have a stop at Peachville, but the settlement was in Oceana County, not in Riverton—Peachville was the old name for Crystal Valley.

# SHERIDAN TOWNSHIP

Sheridan Township was part of Sherman Township when the latter was created in 1867 and was frequently called East Sherman. On October 8, 1888, residents applied to the county board to leave Sherman and become a new township called Lake (although that name was already being used). The county supervisors granted the petition and set up inspectors to supervise the next elections. On October 22, the inspectors requested that the name for the township be changed to Sheridan for Civil War general Philip Sheridan, and so it became.

Around 1882, Alden Batcheller built a mill on the east shore of what was formerly Turtle Lake, which became Batcheller Lake, and as often happens, a settlement grew around it. A few news articles state that the railroad came first, but that seems doubtful; the Pere Marquette Railroad moved its depot from Tallman Village (at the bottom of the township) to Batcheller to service the new mill. In those days, the old depot would be loaded on a boxcar and moved to the next location. The Batcheller Village Post Office was in Section 29, at Morse and Sugar Grove Roads. The settlement also had three stores, a train depot, homes, two hotels and a boardinghouse. A naming problem arose when the post office was designated Bachelor, not Batcheller. The residents seemed to prefer the shorter version of the name. A school was built at the corner of Campbell and Sugar Grove Roads. In 1892, Bachelor Mill and most of the village burned in a fire that started a couple miles away on the O'Donnell farm. With a strong wind, it only took minutes to make it to the town. By the time it was over, only two homes, a

## Sheridan Township
### (East Sherman)

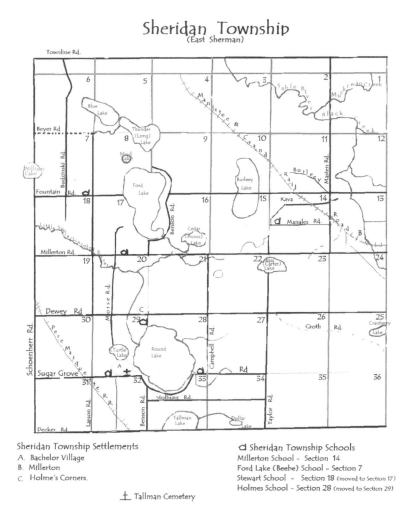

**Sheridan Township Settlements**
A. Bachelor Village
B. Millerton
C. Holme's Corners

ᴅ **Sheridan Township Schools**
Millerton School – Section 14
Ford Lake (Beebe) School – Section 7
Stewart School – Section 18 (moved to Section 17)
Holmes School – Section 28 (moved to Section 29)

✝ Tallman Cemetery

store and the train depot were left. Most of the residents moved away, and the railroad removed the depot. A ghost town it became. It's unclear how many lost their homes and livelihood, but articles by the pioneers state that it had been a fairly large mill operation. Ironically, one of the two houses that survived was the oldest in town.

In Sections 5 and 6 in the northwest corner of the township are Blue Lake (on Larson Road) and Long Lake (on Benson Road), which today is called Thunder Lake. Both lakes are privately owned. To their south is Mud Lake and then Ford Lake (East Fountain Road and Benson Road), which was named after Worthy A. Ford. At one time, Ford Lake had its own phone

company. Ford Lake School, also called Beebe School, was located at the home of John Bauske. It was later moved to the intersection of Fountain and Larson Roads. Stewart School is near the intersection of Millerton and Larson Roads. Originally on the northwest corner of the intersection, it was later moved to the east side of Morse Road at Millerton Road.

In the southeast corner of Section 28 is Round Lake, which had a resort at one time, but it burned. Sheridan Park is on the north shore of Round Lake off Dewey Road.

Holmes School, built in 1876, was in Holmes Corners at the southwest corner of Dewey and Benson Roads. It was later moved to the northwest corner of Campbell and Sugar Grove Roads. The 1915 map shows a school east of Round Lake in Section 30, on the north side of Sugar Grove Road between Larson and Schoenherr Roads. Another school is shown on the 1904 and 1915 maps in Section 17 on the Stewart property at Millerton and Morton Roads.

In Section 13, on the northeast side of the township, was the village of Millerton, where the Manistee & Grand Rapids Railroad met the Sable River at Masten and Manales Roads. Founded in 1897, it was named for John Miller, the area's oldest man, or so he said in an 1898 *Ludington Daily News* article. Some say that it grew around the Canfield Lumber Camp, which owned most of the property around the location, and others insist it was Dodge Squire's Mill (which he bought from F. Young in Fountain and moved to Millerton). Squire built twenty homes for workers, then several stores, a post office and a warehouse, and Lutz & Shramm pickle-making company came. According to Mrs. James Mackintosh, Dodge Squire's granddaughter, the mill burned down in 1901 and was replaced by a larger mill and warehouse. In 1903, the house and store with the post office burned. Squires sold his interests in the mill and village to S.E. Bortz in 1906. The railroad moved its spur from Tallman to Millerton. It was a bustling community until 1921, when the Manistee & Grand Rapids Railroad sold out to the Pere Marquette Railroad, which abandoned service after the mill closed. At that time, the pickle company moved its buildings and vats to Fountain. The people went where they could find work. Millerton School was located at the northeast corner of Millerton and Manales Roads.

Among other places of interest, Muckwan Creek comes down from Meade Township to feed the Big Sable River. Black Creek begins in Elk Township, Lake County, enters Sheridan Township at the northeast corner (near Muckwan) and also feeds the Big Sable River. Cartier Lake is south of Millerton Road in Section 22. The land was formerly owned by Warren

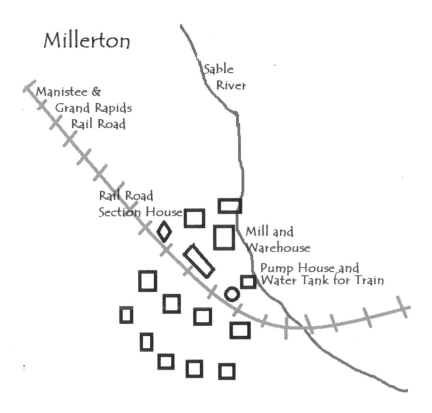

Cartier. Cranberry Lake is in Section 25 on the Mason–Lake County border. Burley Lake lies between Millerton and Ford Lake in Sections 10 and 15 on the old maps but looks to be covered with forest on current maps. Cedar Lake, in Section 16 between Burley and Ford Lake, was also on the old maps but ended up much the same as Burley Lake. Dollar Lake was east of Tallman in Section 34 on the township line.

Per *Historic Mason County*, there is a place along the Lincoln River near Fountain in Sheridan Township where J. McElroy built a lumber camp that was in such a deep forest that it was called Total Darkness.

As with most of the county, there are no mills left in Sheridan Township. Millerton Settlement died with the mill. The same happened to Bachelor Settlement after the fire. Pretty much all that is left is the resort areas around the lakes and river and farms. The post offices, shops and stores are gone. The old Round Lake Hotel still stands but is a private home.

# SHERMAN TOWNSHIP

Named for Civil War general William T. Sherman, who served at the Battle of Bull Run, Sherman Township (including Sheridan) seceded from Freesoil in 1867. Sheridan would remain a part of Sherman for another twenty-one years before separating. Sherman is bounded on the east by Victory Township, the north by Freesoil, the east by Sheridan and the south by Custer. Sherman's early settlers had to deal with swamps, bogs and quicksand. They did so by using poles to probe the swamps (sometimes losing the whole pole) and building corduroy roads. Newspaper articles speak of the need to drain the water underlying the township to get rid of the quicksand by lowering the Lincoln River.

The largest settlement in Sherman Township is Fountain. According to the Fountain centennial book, the name came from a flowing well that resembled a fountain near the railroad water tank erected by N.J. Bockstanz, an early Fountain store owner, in 1881. The settlement was originally plotted by William Rogers in 1883 at Puff's Crossing, about a half-mile south where the Flint & Pere Marquette Railroad track crosses the Lincoln River. When the railroad moved the stop north, people tended to gravitate there. It is said the people preferred to live near the railroad station, which was a short boxcar at first, so the village and post office were relocated. Today it sits in the upper corner of Sections 13 and 14 (see images on pages 119 and 120).

In a 1941 *Ludington Daily News* article, Mrs. V. Chancellor states that the township's first school was built in 1885 at Puff's Crossing.

In 1878, J. Medavis, a Native American minister, purchased forty acres south of Fountain in Section 14. He split this up into small parcels and

# Sherman Township

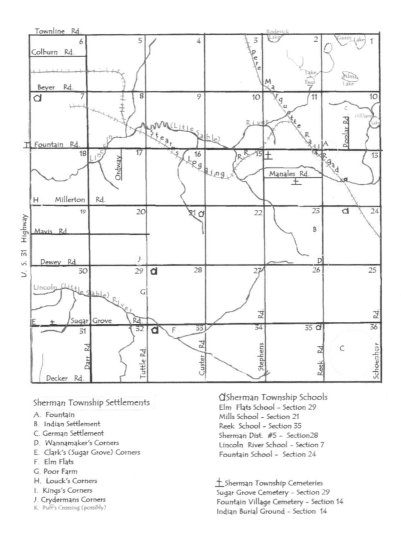

Sherman Township Settlements

A. Fountain
B. Indian Settlement
C. German Settlement
D. Wannamaker's Corners
E. Clark's (Sugar Grove) Corners
F. Elm Flats
G. Poor Farm
H. Louck's Corners
I. Kings's Corners
J. Crydermans Corners
K. Puff's Crossing (possibly)

⌂ Sherman Township Schools
Elm Flats School – Section 29
Mills School – Section 21
Reek School – Section 35
Sherman Dist. #5 – Section 28
Lincoln River School – Section 7
Fountain School – Section 24

✝ Sherman Township Cemeteries
Sugar Grove Cemetery – Section 29
Fountain Village Cemetery – Section 14
Indian Burial Ground – Section 14

sold them to other Native Americans. The westernmost area served as an Indian cemetery. It stopped being used when they began burying people in the south section of the Fountain Cemetery (west of Fountain on Fountain Road near Stephens Road). The Indian settlement formed in the other lots. Chancellor states that there was an old camp farther south on the William Lawrence farm in Section 24 before the Lawrence family moved onto the property.

Per the county history books, Mills School was a small log school built in 1872 in the center of Section 21. There were no roads to the school. In 1885, it was moved to the southwest corner of Millerton and Custer Roads. It was named for Reverend Burton Mills, who helped with the building.

Before there was Fountain, the German Settlement existed in the southeast corner of the township reaching into Sheridan Township. Their German Lutheran church was built in 1883. Obituaries and death certificates indicate that people were buried in the German Cemetery. Careful searching for the cemetery has netted no record of it other than those items. The most logical place would be by the church, but alas, no luck.

Reek School, built in 1872, was in the northeast corner of Section 35 at the southwest corner of Sugar Grove and Reek Roads. Wanamaker's Corners is south of Fountain at Reek Road and Dewey Road (on the east side of the township) and was named for W.H. Wanamaker, who lived on the southwest corner. The community had a blacksmith, carriage and paint shop in 1904.

On the east side of the township, Clark's Corners (Sugar Grove) was at the corner of State Road (U.S. 31) and Sugar Grove Road. The settlement had a general store owned by a man named Darke. It had a post office in one corner of the store and the township library in another. Originally located on the southeast corner of the intersection, by 1904, it was moved to the northeast corner. In the early days, the area had no mills; timber was sent to Tallman. In my day, the Schwartz family owned Sugar Grover Store, and the post office and library were gone. Mr. Schwartz was a walking history book, especially on World Wars I and II. One day, when I asked him if he was afraid of being robbed, he shook his head and pulled out a black pistol, then pulled up his shirt sleeve, revealing the Nazi concentration camp number on his arm. "This won't happen again," he said.

Sugar Grove was given its name for maple sugar, which was one of its industries. Sugar Grove Cemetery is east of State Road (U.S. 31) on Sugar Grove Road.

Another early settlement was Elm Flats, on Sugar Grove Road near Tuttle Road (about two miles east of State Road) in the Lincoln River flats. Elm Flats School was built in 1870 at the southeast corner of Section 33 on former Flint & Pere Marquette Railroad property. A new school was built in 1879. North of Elm Flats is Lincoln River School, built in 1880 near the Beyer Road–State Road intersection. In 1884, it was moved a half-mile south on State Road. Sugar Grove School was on the north side of Sugar Grove Road near U.S. 31. It was built after the 1904 plat book but before the 1915 one.

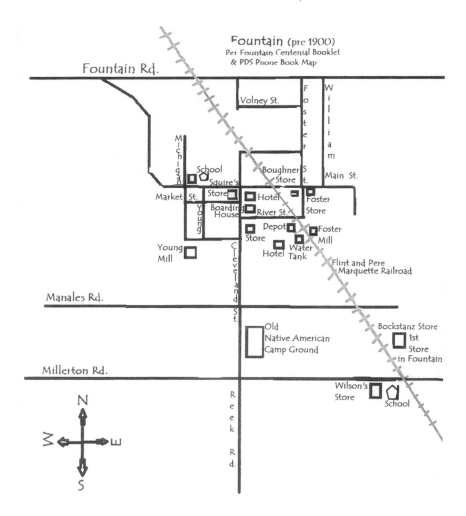

In the same area, the township created a poor farm in 1878 on Tuttle Road, half a mile north of Sugar Grove Road. It evidently didn't pan out and was sold to a private individual in 1886.

Louck's Corners, named for property owner George Loucks, was at the intersection of State Road and Millerton Road. To the north along U.S. 31 at Fountain Road is Kings Corners, named for O.E. King, who lived in the area. At one time, it had a lumberyard, feed mill and store. Today, all but the Kings Corners Store are gone. The lumber store is now Legend's Taxidermy, and next door are two newer buildings, their purposes unknown.

At the intersection of Dewey and Tuttle Roads (Sections 20, 32, 28 and 29) is Cryderman's Corners, named for property owner W.H. Cryderman,

Main Street Fountain. *Courtesy of the Mason County Historical Society.*

who settled there in 1888. On the northern township boundary north of Fountain are the southern shores of Roderick and Gun Lakes (named for Luther Gun). At one time, Gun Lake had a hotel and dance hall. South of that are Alma Lake and Lake Two (which has had that name for over a hundred years). I've heard of Tracy Swamp but cannot find mention of it in the newspaper or history books, nor is it on the plat maps. The 1904 map does show L. Tracy owning forty acres in the northwest corner of Section 10 of the township, so the swamp was possibly named after 1904.

Sherman is the only township that still has a lumber mill: McCormick Saw Mills, on Fountain Road, opened in 1952 and continues the county tradition.

The small settlements are gone, along with their stores and eateries, but Fountain Village has managed to remain, although a shell of what it once was. The village is speckled with empty shops, but at the same time, Fountain Grocery–Gas Station, Head Start, Borema Hamm Insurance Company, Delaney's, the Fountain Area Community Center and the Fountain Senior Citizen Center continue to serve the community. The once-active Fountain lumber and hardware store is now Fountain Menards (not the chain store). The bank may be closed, but in its parking lot is a large ATM from West Shore Bank.

# SUMMIT TOWNSHIP

I n 1859, Summit was the first township created by the Mason County Board of Supervisors. Summit previously had been part of Pere Marquette Township. The smallest township in Mason County, it is surrounded by Lake Michigan to the west, Pere Marquette to the north, Riverton to the east and Oceana County to the south. A history written by township clerk George Collins in 1976 says that the township pioneers named Summit for the tall peaks of the trees and for the high hopes of those living there. A June 29, 1955 *Ludington Daily News* article says that it got its name for the high bluffs, especially at Bass Lake, the highest of which is Mount Eagle Top.

The land along the Lake Michigan shore called Clay Banks for its high banks made up of clay soil includes Pere Marquette and Summit Townships. This is not to be confused with Clay Banks Township in Oceana County. Much of Summit was referred to as Clay Banks. Clay Banks Road is today called South Lakeshore Drive.

The first settlers were William Quevillon, Washington Weldon and Peter LaBelle. Summit's first settlement was LaBelle's Landing (Summit Park today), created by Peter LaBelle. LaBelle's Landing was in Section 23 on the west side of South Lakeshore Drive and Deren Road (LaBelle's Corners).

The landing was the only place in the township where ships came to load and unload their passengers and cargo. Larger vessels would anchor offshore, and scows would make trips between them and the beach with cargo. Boats

## Summit Township

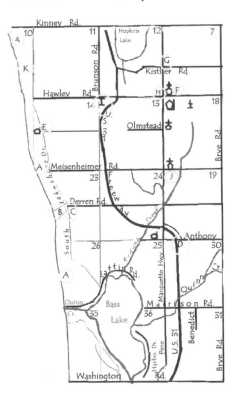

Summit Township Settlements

A. Claybanks
B. LaBelle's Landing
C. LaBelle's Corners
D. Nickerson
E. Fairview
F. Kistler's Grove
G. Kistler's Corners
H. Wesley (French's Corners)
I. Houk's Corners
J. Meisenheimer's Corners (Meisenheimerville)
K. King's Canyon

⌯ Summit Township Schools
Nickerson School - Section 24
Fairview School - Section 14
French School - Section 18

☦ Summit Township Cemetery

would blow their whistles, and locals would come to do the labor, getting twenty-five cents per hour. Many new settlers entered the county through LaBelle's Landing. One of the first lumber camps in the township was at or near the landing and was owned and operated by Charles Mears and William Quevillon. The mill was owned and operated by Charles Sawyer, a future newspaperman. A settlement grew with a mill, store, post office and saloon, and the LaBelle home became a halfway house for travelers. It was a stop on the mail and stage route to and from Pentwater, which was part of the Manistee–Grand Rapids stage. I've heard that LaBelle's Corners was a hit with the Temperance League, seeing as there was one saloon at the landing and another a half mile down the road.

Peter LaBelle is the great-great-great-grandfather of my five sons. He was French and was born in Quebec, Canada. In 1850, he lived in Grand Haven, as did William Quevillon and LaBelle's in-laws, the Gerards. Census records

state that he was a ferryman on the Grand River, which makes operating the landing in our county within his expertise. A newspaper article called him and Quevillon "voyageurs," although there is no proof of that. The two were friends. It is frequently said that LaBelle came in 1858, which sources back to his son Peter Henry LaBelle (called Henry). It's possible he came north alone at first, as his land claim date is December 1855. It is my understanding that the claimant had to spend the next few years improving the property. If this is true, he almost had to come here in 1856, not 1858. Once here, he farmed and ran the landing, which at the time was the only port in the area except Pentwater. His granddaughter, Mrs. Ralph Sheldon, said he died at home at the landing. No death record for him could be found. His burial record just says he died in Ludington, but the records can be inaccurate, and it might have meant the general Ludington area. He was buried in Pere Marquette Cemetery in Ludington. His wife, Maria Gerard, was originally buried on the farm at the landing but was moved to Pere Marquette Cemetery. The foot ferry (which carried foot traffic and carriages) from Pere Marquette Village to Finn Town at one time was run by Maria's brothers, William and Charles Gerard.

The Nickerson area was near Pere Marquette Highway (Old U.S. 31) and Anthony Road. Nickerson School was built in 1864 on the northeast corner then was moved to the northwest corner in 1918.

Fairview was located in Section 14 in the area of South Lakeshore Drive and Olmstead Road. William Quevillon had a post office and store in his cabin beginning in 1860. The cabin is on display at Historic White Pine Village as the Trapper's Cabin (see image on page 125). Quevillon was a trapper who had traveled on the west shore of Lake Michigan. He came to Summit and built a cabin, then later went back for his family in Grand Haven. The cabin was moved in one piece to White Pine Village.

Fairview School was built in 1861 on the west side of South Lakeshore Drive and Olmstead Road. Farther south is Bass Lake, which takes up the southwest corner of Section 5 and the western half of Section 36. The southernmost point of the lake crosses the county line. One of the township's first mills was operated here by Mott and Perkins Company. Bass Lake Park is on the western shore. In 1897, the post office was at Pere Marquette Highway (old U.S. 31) and Marrison Road. The Wishing Well is in Oceana County, on the other side of the road from Mason County. On the southwest shore of Bass Lake was Camp Morrison. It started as an Episcopal boys' camp around 1913. Perhaps it was once a lumber camp before that.

Kistler's Grove was in the southwest corner of Section 7 on Pere Marquette Highway north of Hawley Road. The L.W. Rose Store was in the southeast

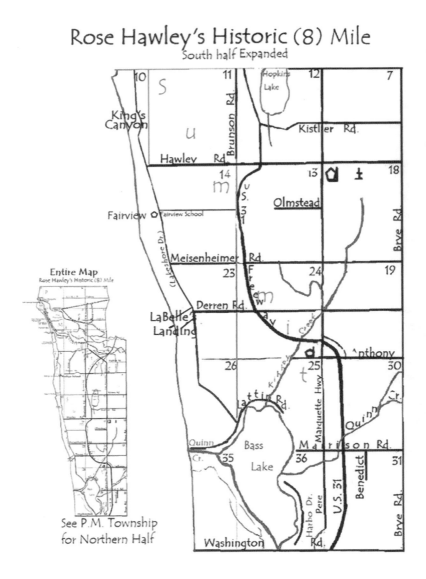

Rose Hawley's Historic (8) Mile
South half Expanded

corner of Section 12 on Hawley Road just west of Pere Marquette Highway. To the northeast, at the corner of Pere Marquette Highway and Kistler Road, was Kistler's Corners, which hosted a pea vinery and Houk's Mill.

French's Corners (at the Wesley Settlement) was at the intersection of Hawley Road and Pere Marquette Highway in Sections 12, 13, 14 and 18. It was the location of one of the pea vineries in the township. Wesley was a stagecoach stop. Named for James French, French School was on the

Quevillon home and post office. The first post office in the county is on display in Historic White Pine Village as the Trappers Cabin. *Author photograph.*

northeast corner in 1868. It was moved to the southeast corner in 1872. L.H. Rose built an implement store here. In a 1941 article in the *Ludington Daily News* on French School District, Lillian Kibbey tells that E. VanAelst had a store and pea vinery at the corners. The Wesley Post Office was in Rose's store.

Houk's Corners was possibly at Hawley and Brunson Roads near pioneer Jacob Houk's property. The other possibility is near Houk's Mill. Meisenheimer's Corners was a settlement at Pere Marquette Highway and Meisenheimer Road. Also known as Meisenheimerville, it had a church, the Broder Blacksmith Shop, a medical doctor, a post office and a general store. It was named for pioneer and store owner Jacob Meisenheimer, who had a mill and basket factory on his farm per a 1941 *Ludington Daily News* article written by Lillian Kibbey.

Kibbey Creek begins north of Meisenheimer Road on the old Kibbey farm, crosses Pere Marquette Highway and flows into Bass Lake. One map also names the waterway from Bass Lake to Lake Michigan Kibbey Creek. When I was younger, there was a small rest area with picnic tables there. A small bridge crossed the creek. Today, most of these small roadside rest and picnic areas are gone, replaced by larger rest areas every thirty miles or so.

Although the rest rooms are gone, the small Kibbey Creek picnic area is still there.

Quinn Creek begins in Riverton Township, north of Anthony Road, and crosses Pere Marquette Highway before flowing into Bass Lake.

King's Canyon lay on the Lake Michigan shore east of South Lakeshore Drive at the northwest corner of the township. Owned by Charles and Aurelia King, it was a picnic area with a wooden waterwheel run by a flowing spring that came out of the canyon wall to entertain visitors. (In the dry season, the wheel ran on electricity.) The Kings sold the land to J. Conrad, who dammed up the spring and used it to pump water to his home. Per Betty Anthony, former summit treasurer who grew up at the canyon, it was later sold to Robert Rohn, who was her father's employer. She says that King's Canyon would have been down along the Lake Michigan shore behind Consumers Energy's guardhouse on South Lake Shore Drive.

At the top of the township is the south shore of Hopkins Lake (named for George Hopkins). The majority of the lake is in Pere Marquette Township. An old hand-written essay at the historical society says that Hopkins Lake was also known as Devil's Swamp. It probably seemed like it for new settlers.

King's Canyon Wheel was powered by a small spring that came out of the canyon's wall. *Courtesy of Mason County Historical Society.*

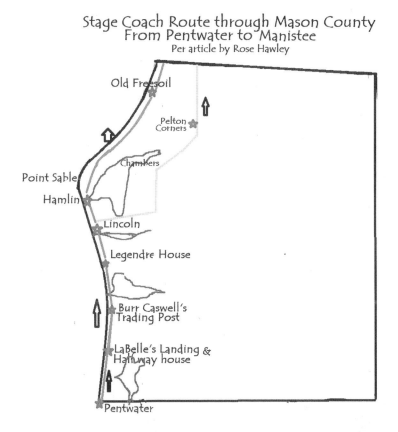

Stage Coach Route through Mason County
From Pentwater to Manistee
Per article by Rose Hawley

Middle Road ran straight through Summit and Pere Marquette Townships. Old U.S. 31 (Pere Marquette Highway) still runs south from U.S. 10 through both townships to Oceana County.

A stagecoach route ran along the county's lakeshore from Pentwater to Manistee. Beginning at Pentwater, it made its first stop at LaBelle's Landing and halfway house and then went up to Burr Caswell's trading post in the Buttersville area. From there, it went down the hill through the Buttersville peninsula and across on the foot ferry to Pere Marquette (Ludington). Back on land, it went up to the Legendre House for a stop. The Legendre House was a halfway house like LaBelle's where people would stop while traveling to rest, eat and be entertained. The house was located where the Ludington Water Plant is today north of Stearns Park. From there, it went on up to Lincoln and Hamlin Villages. After a stop, it continued up along the old mail road to Old Freesoil and on to Manistee. Once Freesoil Mills closed, the path

went across to Dennis Road and up to Chambers and then Pelton's Corners. With fresh horses, the stage continued up into Manistee County.

Summit's lumber industry is gone, and with it the various settlements. Summit has no settlements today, and on the surface, it is a farming community. Although most of the land is tied up in fruit farms, the major industry is the Consumers Energy–DTE Hydroelectric Pumped Storage Plant, which it shares with Pere Marquette Township. Farther south on Lakeshore Drive, across from the old LaBelle property and LaBelle's Landing—which Uriah Bortell, an early settler, purchased from the LaBelle family—is Bortell's Fisheries. They sell fresh fish and fried fish and chips, which they cook as you watch. They have some of the best fish in the county. Today, LaBelle's Landing is Summit Park, and thanks to the Summit Township community, it has one of the nicest child play areas in the county. It has a new sailing vessel where children can climb a net, slide down slides, fire cannons and even walk the plank.

Farther south is the busy Bass Lake area, which still has resorts and campground.

# VICTORY TOWNSHIP

Previously part of Lincoln, Victory Township was formed in 1867. It was bounded by Hamlin Township on the west, Freesoil on the north, Sherman on the east and Lincoln (today part of Amber) and Amber on the south.

A historical sketch in the February 25, 1941 *Ludington Daily News* says that Victory got its name from a time when the people of Bird Settlement won a war of words. Other articles suggest that the name comes from the victory of the North against the South in the Civil War.

The first settlement in Victory was at Bachus Landing, built in 1863 along the Lincoln River near Victory Corner and Fisher Roads. It was named after John Bachus, who came to the area in 1863. After his visit, Bachus returned to Ohio and spoke about Victory. Several people, including the Knox brothers, followed him back.

Victory Corners, settled in 1866, was originally called Bird Settlement and then Rayne's Corners and Forest City (see image on page 132). The settlement in its heyday had a greater population than Ludington, with a mill, a hotel, three stores a half-mile apart (including Bachus's store and Richard Rayne's), a post office, a saloon, Dr. Timothy Knox's office, a newspaper printer, two blacksmiths and a wagon shop. All were located around the intersection of Fisher and Victory Corners Roads in Sections 32 and 33. Bird Settlement was named for early settler N.L. Bird, who came in 1862. During its heyday, Victory Corners was home to over five hundred people. All of these people and the merchants were hoping the Flint & Pere Marquette Railroad would come

# Victory Township

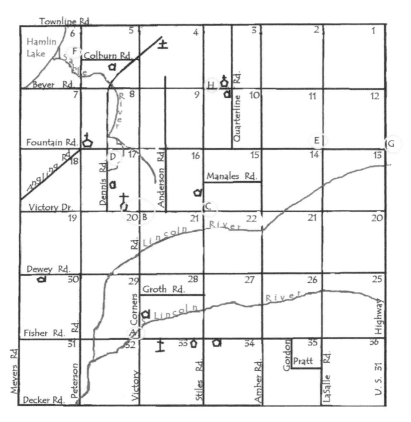

through Victory to make their lives and travel easier. When the railroad went south of State Road and put a station at Amber, Victory Corners' hopes were dashed, and many of the residents relocated to Amber. The settlement began to disappear in 1871, and by 1874, when the railroad reached Ludington, Victory Corners was a ghost town.

The Knox brothers, Dr. Timothy and Hosea, came from Ohio in 1864 and built Knox Mill and Dam on the Lincoln River north of Bird Settlement.

South Victory Cemetery is east of the corners on Fisher Road. Victory Corners School was built in 1866 on the west side of Victory Corners Road between Groth and Fisher Roads. It was moved across the road in 1895.

The Danish Settlement was north of Victory Corners. Founded around 1871, it was a large area of farms owned by Danish settlers. The Danish Lutheran church was located on the northwest corner of Victory Drive and Victory Corners Road. The settlement was also called Poulsen or Paulsen in 1897, possibly after Danish settler Pete Paulsen, who lived across from the church.

The Roach Canning Company had a pea vinery on the Carl Peterson farm at the intersection of Victory Drive and Victory Corners Road.

The town hall was at the northwest corner of Victory Drive and Stiles Road. Town Hall School was just to the north of the hall. Probably located in the area of Dewey and Peterson Roads, south of where Sacred Heart Catholic Church was located, Krafts Corners (Thompson's Corner) was named after Rinehart Kraft, who owned the property at two of the corners. In Section 30, in the township's southwest corner, was Dewey School, built in 1898 at the southwest corner of Dewey and Peterson Roads. In the northwest corner of the township, Chapel Corners was located at North Dennis Road. It was the location of a half-built chapel and a post office. Newspaper articles say that the chapel was never finished.

Banner School was on the east side of Dennis Road between Victory Drive and Fountain Road in Section 17. In a 1941 *Ludington Daily News* article, Mrs. Henry Martin states that the Old Manistee–Lincoln Stage Road passed through the Dolan, Brown and Laidlaw farms in the Banner District. James Dolan ran a halfway house where the stagecoach driver and mail carrier, Cornelius Smith, and horses could rest. The article says that the coach ran from Pentwater to Manistee. That halfway house still stands down the road from Orchard Market.

Keith's Corners is a mile west of King's Corners at Fountain and LaSalle Roads.

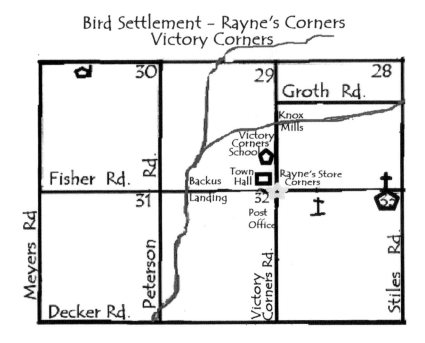

Bird Settlement - Rayne's Corners
Victory Corners

Star School was in the northeast corner of the township on the south side of Sugar Grove Road at LaSalle Road.

Little Sweden, in the northwest corner of the township, was formed by Swedish immigrant farmers. Nearby, Chambers was at the mouth of the Sable (or Sauble) River. The Chambers District was named for Dr. E.C. Chambers, a minister and a former Pentwater undertaker who moved to the area. Chambers School is on the west side of Dennis Road at Colburn Road. Also at the northwest corner of the township was LaCarp, nine miles north of Lincoln. William Barnhart was the first postmaster.

Another settlement in the northwest was Lakeview. Research could find no clue to its location other than its name. It had a lake view, and the only lake in the township is Hamlin, which also happened to be in the northwest of the township.

LaSarge's Corners is at the intersection of Beyer and Stiles Roads, near the C. Millwood and F. Johnson properties in Sections 4 and 9. Also, near Beyer Road, in Section 10, is Diamond School. It is in the north of the township at the southwest corner of Beyer and Quarterline Roads. Gutshaw Cemetery (North Victory Cemetery), named after John Gutshaw, on whose property it was created, is on North Dennis Road just south of Townline Road.

The northeast shores of Hamlin Lake are in Sections 6 and 7. The Big Sable (Sauble) River comes in from Freesoil and flows to Hamlin Lake. The Little Sable (Sauble) River was later renamed the Lincoln River. It enters the township from Sherman Township at Section 13, flowing southwest into Amber Township at Section 32. Costello Creek begins east of Stiles Road, above Manales Road, and crosses Victory Drive, flowing to the Lincoln River. Burr Creek begins east of Victory Corners Road, crosses Dennis Road and flows to the Lincoln River. Davis Creek begins near Townline Road in Section 11 and flows west across sections 10, 9, 8, 6 and 5 into Hamlin Lake.

Victory was one of the active early townships in county history. Victory Corners, one of the largest settlements in the county, had everything going for it until the railroad decided to go elsewhere. The mill, store and doctor moved to Amber, as did many of the people. Some of the descendants of the early settlers remain on family farms. West Shore Community College is the main employer and brings hundreds of people into the township. To the north of the college, Victory Early Childhood Center is located in one of the few rural schools being used today as a school, Victory Elementary School. To the south of the college is Country Veterinary Clinic and Kennel, which services many of the rural residents and farms.

# CONCLUSION

Now that our journey through Mason County's lost settlements is finished, I hope you get out there and visit some of these wonderful places. Before ending, please let me pull together some of the loose threads that need tying up. As I said in the beginning, Mason County had two cities, six villages and thirty-nine settlements. Today, most of these settlements are completely gone. Why did some settlements succeed and some fail? Let's take a quick look back at *National Geographic*'s reasons for settlements: purpose and location.

## AMBER TOWNSHIP

Amber Corners had a store and a post office for the locals but no industry to supply work for people. It was located on State Road (U.S. 31) in horse-and-buggy days. When the train went to the south and created Amber Station, the purpose for Amber Corners ended. I don't think Amber Station had a purpose other than a station; it didn't have jobs for its residents. Although it had a good location in the beginning, when automobiles came along, people found the train somewhat limiting.

Many say that Jordan Settlement became Scottville. I think that Jordan was in a bad location, too close to Scottville and Amber Station. It was a station with four blocks for homes and industry that didn't seem to come. There was no purpose for it to be.

Scottville had transportation, industry, merchants and people. But its industry was around farming. As farming practices changed toward the big farms, most small farms disappeared. Thus, the farm industries, like tractor and implement sales, are gone. The large farms own semi-trucks and trailers to haul their product to the receiving stations, so the local gristmills and farm supply businesses failed. At one time, Scottville had two or three car dealers, but all moved to the U.S. 10 corridor. Even my insurance dealer has left town. Today only Acres Co-Op survives on U.S. 10. As a rural Scottville girl, it has saddened me deeply to see my hometown dwindling. It has failed to evolve. It remains a city, but for how long?

## BRANCH TOWNSHIP

Branch began as a resort settlement surrounded by lumber camps. It later acquired a farming industry. Thus, it began with a purpose, and it had a good location, with the railroad going through and the state highway. It was bypassed by a state highway, and businesses failed to evolve, which is why it is dying.

Tallman Village had everything going for it: industry, merchants and transportation. It all ended when the mill burned. Today, all that can be found are the lake, declining roads and the senior citizen center.

Butters Junction/Walhalla went hand-in-hand with Tallman, but it also had businesses on a main highway. Still, little is left.

Swedish Settlement was a lumber town/camp. When the mill burned, the settlement died.

## CUSTER TOWNSHIP

Custer Village had all the ingredients of a successful village. Its mills, factory and farms and the railroad going through seemed a winning combination. But when the lumber industry began to fail, so did the town. Today, large farms help the community, but is it too late? I hope not.

Herrickville had a purpose and river transportation, but that was all. It died with the lumber industry.

Dunkard Settlement was bought out by farmers and was absorbed into the area.

Bonser's, in Custer, is pictured in 2018, after it closed. I edited the store name to be near the giant head to get both in the picture. They made the best turkey jerky I've ever had. *Author photograph.*

## EDEN TOWNSHIP

Fern had a mill and transportation, but the mill closed, and the railroad pulled up. It had no industry other than farming. Large families made jobs outside the family scarce, and when the train pulled out, Fern was isolated.

Wiley has always been a farming area and dependent on nature. When a drought came, the pea vinery died. When the lumber industry died, the train pulled out, and the main source for transportation was lost for the creamery.

Fosterville fit the definition of a settlement: it was more of a family business. There was no attempt to bring people in or ally with others. Besides, the location was poor.

For the Native Americans who were forced to the Indian reservation—what was called Indiantown—the change of lifestyle was too big to adapt to. Most left and went north.

## FREESOIL TOWNSHIP

Tallman's dream settlement in Freesoil Township just never took. Although it was on the railroad line, it really didn't have a strong enough purpose.

Freesoil Village seemed to have a purpose and the location for success. So what happened? It's not certain, but it seems that it failed to evolve with

the times after the end of lumbering. When autos came about and with the advent of big chain stores, the mom-and-pop businesses couldn't compete. The same can be said of all the small businesses in the county.

Pelton was built around a school. It had a post office and a store, but it had little to no industry. It was an important stop and refresh spot for the stagecoach, which no longer runs. It was located on the north state road, but without cars, that was useless. Across the road, the Orchard Market is doing well; its farms provide work for many, as does the store and restaurant, and the food is very good, too. But Orchard Market came about later. Freesoil is home of some of the nicest people in the county; let's get to work and find a way to save this village.

Meadeville didn't have a chance. There was no industry and no merchants. The village seemed well placed, but the rest of the settlement was in a poor location. Most of all, it was a con, which seemed to doom it from the start.

## GRANT TOWNSHIP

Freesoil Mills were built and lived on the lumber industry. Lake Michigan provided transportation. But nature intervened, and when a fire burned the mill down a second time, it was done.

Siddons did have a post office and printer. But it was in lumber territory and died with the industry.

Sable Settlement grew around the river and lumber. Like the rest of the county, it failed with the lumber industry.

## HAMLIN TOWNSHIP

Big Sable/Hamlin again had all that was needed: industry, homes, material supplies and even transportation. Unfortunately, nature took it out. Today, though, it is a vibrant tourist area full of summer cottages and permanent homes.

## LINCOLN TOWNSHIP

Little Sable/Lincoln Settlement had everything that a community could need: industry, merchants and transportation. But it ran out of material

for its purpose—the lumber industry. It didn't evolve to keep the jobs and people there. And when Mears moved to Chicago and left the place in the hands of others, it lost its vigor.

## LOGAN TOWNSHIP

Abbot was never a settlement at all, but the U.S. Postal Service felt it was.

Carr may never have had a lot of businesses, and Carr Telephone, now called Carr Communications, is the only one that survives to this day.

Carr Communications wisely brought its telephone business into the new millennium by adding internet and TV service. *Author photograph.*

The Ludington Freedom Festival mural was painted by Terry Dickenson, of Kingsley, Michigan. *Courtesy of Amanda Malburg.*

Carr Settlement was dependent upon the logging industry. Although there were farms, that didn't support a community. The isolated location in the county made travel difficult.

Ruby Creek had Roby's Mill, but it never really evolved past that.

## PERE MARQUETTE TOWNSHIP

Buttersville was a standalone community. Along with Seatonville and Taylorsville, it was an industrial powerhouse. They were in a great location. When the lumber industry began to fail, Butters evolved and opened a salt block. Fire had the final say with these communities. Oddly, surrounded by water, none could be saved.

Finn Town was a fishing settlement that had an awesome purpose and great location. Unfortunately, the settlement didn't own the land it was on, and the people were evicted.

Ludington/Pere Marquette Village did it right! The city founders actively sought out industry, transportation, merchants and people. It couldn't have a better location, which is why it is still a bustling city. Pere Marquette was hijacked and became the Ludington we know and love. To celebrate the county's shipping history, a new museum was created.

Polish Town land was sold to Dow, and the residents were absorbed into the Fourth Ward.

## RIVERTON TOWNSHIP

Center, East and West Riverton were in farm areas, and the industry that sprang up was related to farming. The farmers logged to clear farmland. When the railroad went through, it provided jobs, but when it pulled up tracks, there was no work other than farming, and people had to leave. Most farmers in those days had many children, so outsiders were usually not needed to run the farms.

Egypt was a settlement in someone's dreams, and that's it. I sometimes wonder if it was a joke aimed at us Edeners.

Buck's Corners and Squireville were family farm settlements. There were only so many farms for so many people. Kids move to better locations where the work is.

Meisenheimerville had several things going for it: a mill, basket factory, vinery, several businesses, a doctor and farms. It was near State Road but no other transportation. It was a farm community but dependent upon the timber industry. People moved with the jobs, and it lost its purpose for being.

## SHERIDAN TOWNSHIP

Millerton was formed around the railroad. Lumber and the pickle industry came in. It was too dependent on the lumber industry, and when that died, the settlement lost the railroad, and it failed.

Elmton, as far as could be discerned, is a name on a map. People mentioned it in their articles but said little else.

Bachelor had all the ingredients for a successful village. It had industry to supply jobs. It had businesses for people to get supplies from and a railroad to deliver those supplies. Unfortunately, it and its forest were destroyed by fire, and the settlement was not rebuilt.

The Fountain horse pull statue reminds me of the persistence of the people of Fountain. It was created by Reuben Llano of New Era. *Author photograph.*

141

## SHERMAN TOWNSHIP

Fountain had plenty of industry and merchants. However, it was another lumber town and took a major hit with the downfall of that industry. It had a good location on a railroad line. It should have died with the lumber industry, but I believe its people are the key to its survival. Their feistiness and willingness to work to keep their community are its best product. However, if it wants to stay alive, it needs to evolve.

## SUMMIT TOWNSHIP

Fairview was a school and post office. It had no industry and no transportation. William Quevillon's post office and store were in his log cabin on his farm.

LaBelle's Landing was a port. It had a purpose and great location, it was just outclassed by the new harbor at Ludington. Further, the death of Peter LaBelle ended the family's efforts at the landing.

## VICTORY TOWNSHIP

The Danish Settlement was a farm community. Although it probably had cottage industries, many workers had farms but walked to mills nearby. I don't think it aspired to be bigger. The location was isolated.

Victory Corners had everything you would think people would need, even a few of the wants. It had industry and transportation by the river. The mill needed the railroad to bring more lumber in and transport it to market. With the mill went the jobs. Its location in the day of the horse and buggy wasn't the best.

*\*\*\**

SO, WHY DID SOME of the settlements fail? Barring natural disasters, it was failure to evolve. If one industry fails, you need to find something else to take its place. If you have no transportation, build a stagecoach to haul people, as Harry Barnett did in Branch. Evolve. As in nature, it is survival of the fittest!

# APPENDIX

Some lost settlements have eluded careful search, some with reason—specifically Amasa (possibly Amber Township), Greenway Creek (possibly Custer Township) and Coon Hollows Landing.

Several bygone settlements other publications claimed to be in Mason County, as stated in previous pages, are located in other counties:

Sheepdale—a Google search comes up with a travel page (Roadside Thoughts) that places it in Lake County but doesn't know where. It is in none of the history resources or maps.

Sweetwater—a township and settlement near Branch Township, Lake County.

Stearns Siding—Justus Stearns's first lumber camp and mill in Sweetwater Township, Lake County.

Peachville—is Crystal Valley, Oceana County.

Woodburn—is south of Fern and across the Pentwater River in Oceana County between Crystal Valley and the Mason County line.

Craw Wingle—a Dutch settlement that was attributed to Mason County in a book on ghost towns. My research has found in the 1882 book *History of Manistee, Mason and Oceana Counties, Michigan* that Craw Wingle was in Oceana County. I can find absolutely no evidence that it was ever in Mason County.

Goodrich—is South of Crystal Valley in Oceana County.

I have tried to cover all that is left of every settlement in this county. If I left anyone out, I sincerely apologize.

# SOURCES

## PERIODICALS AND NEWSPAPERS, 1873–2018

I have made frequent use of the *Ludington Daily News*, especially regular columns by the following: James Cabot, Georgia (Mrs. V.H.) Chancellor, G. Pearl Darr, Truman French, George Griswold, David K. Petersen, Paul S. Peterson, Bob Scully, Jean Stickney, Lenore Williams and George Wilson. The February 25, 1941 and June 29, 1955 issues proved especially useful. I have also made use of the Community News columns in the *Ludington Appeal, Ludington Record, Ludington Record-Appeal* and *Ludington Chronicle*. The Mason County Historical Society and Rose Hawley Museum published a quarterly journal, *Mason Memories*, from 1971 to 1989 that was a great source of information.

## BOOKS AND ONLINE RESOURCES

Anderson, Dr. William M. *Victory Township*. Charleston, SC: Arcadia Publishing, 2007.

Anderson, Russell F. *Historic Not-a-pe-ka-gon*. Ludington, MI: Lakeside Printing, 1933.

*Atlas and Farm Directory of Mason County, Michigan.* Chicago: Standard Map Company, 1915. Accessed March 25, 2019. http://www.historicmapworks. com/Atlas/US/12144/Mason+County+1915/.

Council for the Humanities. *Our Towns Revisited: Communities of Northern Michigan.* Detroit: Eastern Michigan University, 1989.

Garasha, Robert. *Mason and Oceana Railroad.* Ludington, MI: Lakeside Printing Company, 1953.

Geography Education National Implementation Project. "Geography Standard 12: The Processes, Patterns, and Functions of Human Settlement." *National Geography Standard.* National Geographic Society. Accessed March 25, 2019. https://www.nationalgeographic.org/ standards/national-geography-standards/12/.

Hanna, Frances Caswell. *Sand, Sawdust and Saw Logs: Lumber Days in Ludington.* Ludington, MI: 1955.

*History of Manistee, Mason and Oceana Counties, Michigan.* Michigan County Histories and Atlases. Chicago: H.R. Page, 1882.

Mason County Historical Society. *Historical Mason County.* Dallas: Taylor Publishing, 1980.

Petersen, David K. *Mason County: 1850–1950.* Charleston, SC: Arcadia Publishing, 2015.

———. Mason County History Companion. Accessed March 25, 2019. http://www.ludingtonmichigan.net/.

Peterson, Paul S. *The Story of Ludington: Born of Logs, Nurtured by Carferries, Forged by Resilience.* Phoenix: Heritage Publishing, 2011.

Powers, Perry F. *A History of Northern Michigan and Its People.* Chicago: Lewis Publishing, 1912.

Russell, Curan N., and Donna Degen Baer. *The Lumberman's Legacy.* Manistee, MI: Manistee County Historical Society, 1954.

*Standard Atlas of Mason County, Michigan.* Chicago: Geo. A. Ogle, 1904. Accessed March 25, 2019. http://www.historicmapworks.com/Atlas/ US/16834/.

Stickney, Viola. "Echoes of Eden." Unpublished manuscript, 1958. Mason County Historical Research Library.

Walling, W.F. "Map of Mason County, Michigan." *Atlas of the State of Michigan.* Detroit: R.M. and S.T. Tackabury, 1873. David Rumsey Map Collection. Accessed March 25, 2019. http://www.davidrumsey.com/ maps730119-22367.html.

## VERBAL SOURCES

Betty Anthony, former Summit Township treasurer
Dan Bissell, car ferry historian
Bruce Burke, Logan Township supervisor
Gary Ditmer, formerly with the Mason County Road Commission and Riverton resident
James Gallie, Amber Township supervisor, formerly with the Michigan Department of Natural Resources
Ann Hassenbank, former Freesoil Township clerk
Mary J. Janowiak, Grant Township clerk
Betty Johnston, Carr Settlement historian and Find a Grave contributor
Shawl Keith, Sugar Ridge Church minister
Don Klemm, C&O Railroad historian
Greg Kojlhede, White Pine Village interpreter
Lois Krepps, Meade Township supervisor
Tom Leonard, Freesoil postmaster
Ron Lessard, C&O Railroad and Ludington historian
Lillian Lipinski, neighbor
Henry J. and Clara Malburg, father- and mother-in-law
Roger Nash, Eden Township supervisor
Alice Pomrenke, neighbor
Carrie Powers, White Pine Village interpreter
Ila Price-Smith, Custer historian
Sally Razminaz, Branch Township researcher
David Sherburn, neighbor and lifelong Wiley resident
Michael Shoup, Branch Township supervisor
Charles Stickney, former Eden Township supervisor
Don and Estelle Stickney, neighbors
Erv Stovesand, neighbor
Ron Wood, farmer and Mason County Historical Society member

## MASON COUNTY HISTORICAL SOCIETY FILES AND NEWSPAPER CLIPPINGS

This list was formed as I went through my township files and alphabetized, so placement has nothing to do with importance.

William Alexander, *Ludington Daily News*, 1938

Glenna Anderson, *Ludington Daily News*, August 17, 1987

Lila Arthur, *Ludington Daily News*, March 23, 1964

Alice Bahr, *Ludington Daily News*, February 25, 1941

Opal Bailey, essay

Mrs. Frank Barclay, *Ludington Daily News*, February 25, 1941

Helen Bartlett, *Ludington Daily News*, no date on article

Mrs. Frank Beaunne, *Ludington Daily News*, no date on article

Mrs. Fred Beebe, essay

Mrs. T.L. Beebe, *Ludington Daily News*, February 25, 1941

Edith Benz, *Ludington Daily News*, February 25, 1941

Selva Beyer, *Ludington Daily News*, February 25, 1941

Bertha Bigford, *Ludington Daily News*, February 25, 1941

Mrs. J. Harold Birdsall, *Ludington Daily News*, February 25, 1941

Hanna (Mrs. Charles) Bittell, *Ludington Daily News*, February 25, 1941

Mary Blodgett, *Ludington Daily News*, no date on article

Veronica Blumber, seventh grade, *Ludington Daily News*, August 16, 1923

Ella Broder, eighth grade, essay

Estelle Brown, *Ludington Daily News*, February 25, 1941

H. Maurice Butler, *Ludington Daily News*, April 19, 1940

Mrs. John A. Butz, *Ludington Daily News*, February 25, 1941

Liola K. Coleman, *Ludington Daily News*, 1986

George R. Collins, letter

Beatrice and Jamie Cowell, essay

Richard Dancz, *Ludington Daily News*, March 19, 1969

Minnie K. Dean, notes

Dawn Dornobos, *Ludington Daily News and Mason Memories*, 1975 and 1976

Mrs. Fred Dostal, notes

Shirley Edmonds, essay

Ellen Egbert, *Ludington Daily News*, no date on article

Azora Figgins, *Ludington Daily News*, no date on article

Elizabeth Fisher, essay

J.F. Fitch, notes

Julia Genson, letter

Hester Gordon, *Ludington Daily News*, February 25, 1941

Mrs. William Groth, *Ludington Daily News*, February 25, 1941

Henry Guernsey, essay

Mrs. Marshall Gulumbo, *Ludington Daily News*, February 25, 1941

Bert Hall, essay

Frances Caswell Hanna, *Ludington Daily News*, 1955

Jerome Harmon, essay

Rose Hawley, author and director of Mason County Historical Society, *Ludington Daily News*, 1950–1963

Mrs. John Hemmer, *Ludington Daily News*, February 25, 1941

Mrs. Hiram Herrick, *Ludington Daily News*, no date on article

Mrs. Sam Hjortholm, *Ludington Daily News*, November 14, 1959

C. Howard Hornung, thesis

Mrs. Grant Huffman, essay

Mrs. Alford Hull, *Ludington Daily News*, February 25, 1941

Mrs. Frank Hunt, *Ludington Daily News*, 1942–1957

Margaret Hunt, letter and essay

Ruby Jenson, *Ludington Daily News*, January 19, 1955

Hilda Johnson, eighth grade, *Ludington Daily News*, no date on article

Mrs. Charles Johnson, *Ludington Daily News*, February 25, 1941

Eugene Jorrisson, letter

Mrs. Edward Karas, *Ludington Daily News*, February 25, 1941

Frank Kibbey, *Ludington Daily News*, July 30, 1941

Lillian Kibbey, *Ludington Daily News*, February 25, 1941

Julia Lawrence, essay

Jacob Lunde, *Ludington Daily News*, February 25, 1941

Agnes MacLaren, *Ludington Daily News*, 1942–1949

Edward Marquardt, *Ludington Daily News*, December 21, 1941

Harriet Martin, *Ludington Daily News*, February 25, 1941

Lillian Mayer, essay

Luella McCumber, eighth grade, essay

Ivah McIntosh, essay

Margaret McKee, *Ludington Daily New*, February 27, 1942

Mabel McKenzie, *Ludington Daily News*, 1941 and 1955

Carrie E. Mears, *Ludington Daily News*, March 13, 1944

H.M. Miller, *Ludington Daily News*, November 9 1961

Mrs. V.C. Miller, *Ludington Daily News*, February 25, 1941

Mr. and Mrs. Arnold Nelson, *Ludington Daily News*, no date on article

Viola Nelson, essay

Connie Newkirk, *Ludington Daily News*, no date on article

June Newkirk, *Ludington Daily News*, June 25, 1972

Mrs. Kenneth Parker, *Ludington Daily News*, no date on article

Henry Patterson, *Ludington Daily News*, 1923

William Perring, notes
Mrs. Max Rahn, essay
Doris Reid, *Ludington Daily News* and notes, no date on article
Mrs. George Riley, *Ludington Daily News*, February25, 1941
Mrs. Ralph Sheldon, notes and *Ludington Daily News*, no date on article
William Sommerfeldt, *Ludington Daily News*, 1946 and 1955
Ella M. Stephens, *Ludington Daily News*, 1941 and 1955
Altah Striker, eighth grade, essay
Cleo Stuart, *Mason County Press*, October 5, 1967
Hazel Stuart, *Ludington Daily News*, February 25, 1941
Pearl Stuart, *Ludington Daily News*, no date on article
Betty Taube, essay
Winifred Clark Tobey, *Ludington Daily News*, 1955 and 1956
Dorothy Treblecock, Ludington *Daily News*, no date on article
Mrs. William Tucker, *Ludington Daily News*, no date on article
Ruth Van Molen, *Mason County Press*, October 8, 1958
Elda VanNortwick, *Ludington Daily News*, April 25, 1944
Johanna Wilson, *Ludington Daily News*, no date on article
Edith Wing, essay
George Wyant, *Ludington Daily News*, no date on article

There were hundreds of untitled notes, letters and essays in the historical society's files. They were every bit as helpful as the above, but I am unable to credit the authors for their help.

# INDEX OF PLACE NAMES

Respective townships are included in parentheses.

# ABOUT THE AUTHOR

Sandi Lewis-Malburg is the mother of five sons—Nicholas, Timothy, Andrew, Gabriel and Noah. A graduate of Mason County Central schools, she earned an associate's degree from West Shore Community College and a bachelor of science degree from Grand Valley State University. An avid amateur genealogist, she has photographed eight Mason County cemeteries for the Find a Grave website. She has lived most of her life in Mason County, where she often works as a volunteer. She taught at Baldwin Middle and Senior High Schools in Lake County, Michigan. Now retired and living in Amber Township near Ludington, she spends most of her days in research and writing or with her grandchildren.